The Living Stones of Cairo

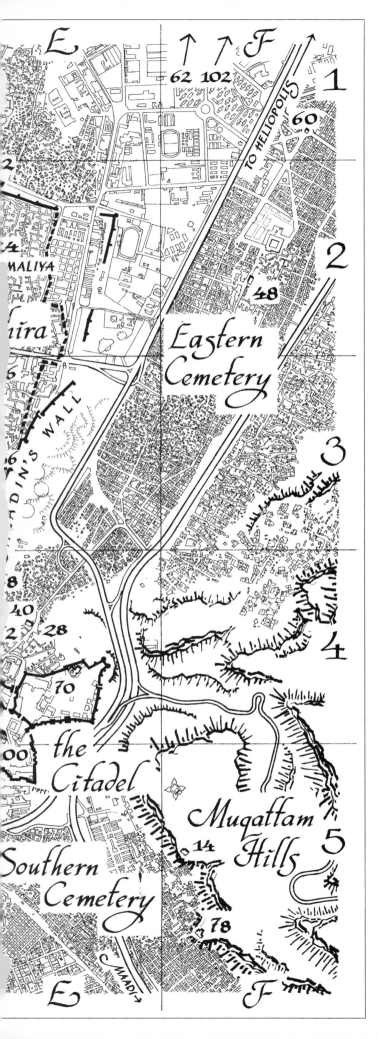

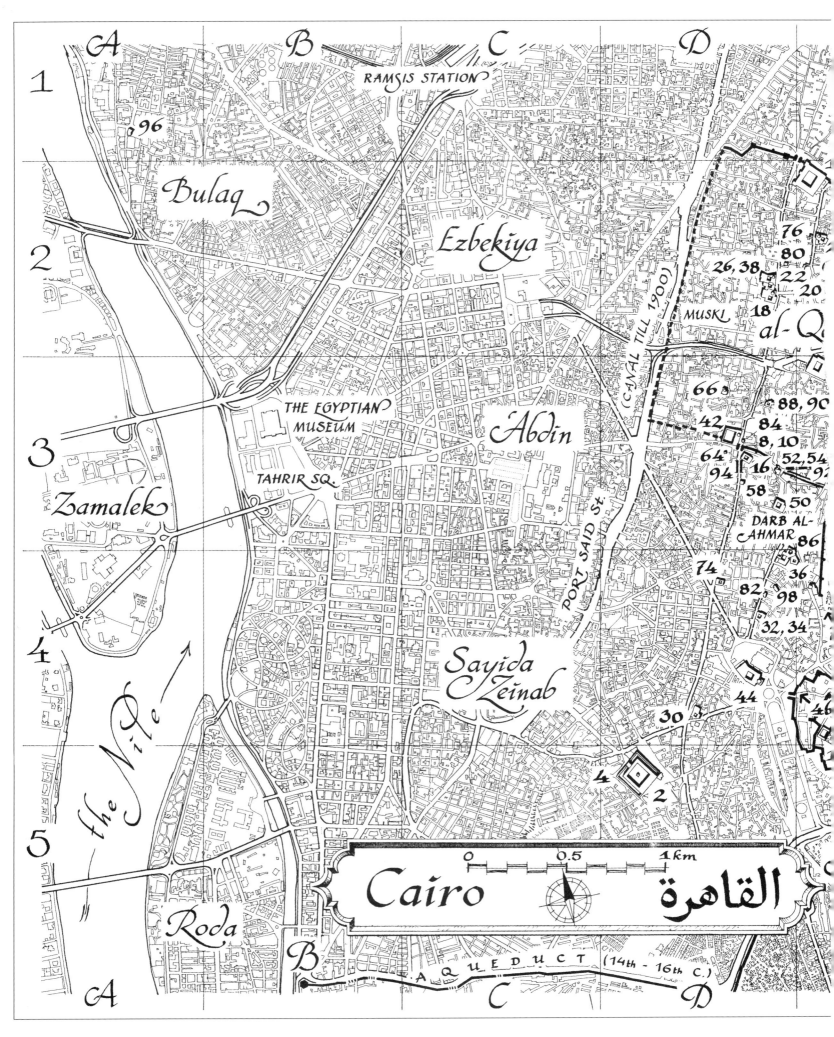

The Living Stones of Cairo

Jarosław Dobrowolski

The American University in Cairo Press
Cairo • New York

Dar el Kutub No. 1787/00
ISBN 977 424 632 2

Designed by the AUC Press Design Center/Andrea El-Akshar
Calligraphy by Jarosław Dobrowolski
Printed in Egypt

Contents

Contents

Contents

Preface

A stone is the epitome of solidity, immobility, lifelessness. Yet in Cairo, stones are alive. This is perhaps not surprising, considering that the medieval city grew in a land that had excelled in monumental stone architecture for well over three thousand years. In Cairo, the ingenuity of architects and the mastery of craftsmen made stone turn, bend, and tangle in carved lines, soar in lofty domes, creep in flowing inscriptions, dance in the haze in the city's skyline of crenellations, domes, and minarets. They knew the magic that could make the solid mass of a huge dome swirl with twisting ribs or blossom with floral patterns.

The stones of Cairo live in another sense, too. The buildings are alive with the memories of people. Every actor in the bloody drama of Egypt's medieval history was eager to leave behind a mark built in stone, and the buildings tell the story of passion, rivalries and conspiracies, alliances and frauds, loyalty and treason, majesty and baseness.

They are alive in yet another way. Like people, they age and suffer, they grow weak, and they can be sick, poisoned by contaminated groundwater and polluted air. They die, turned into powder by disease or smashed by the unstoppable growth of the modern metropolis of concrete and steel.

The drawings in this book were made over a period of more than ten years. All were sketched from life (not an improper expression, I believe, when one speaks about the stones of Cairo), during leisurely walks through the city, completely unrelated to my professional activities as a conservation architect. Many originate from the time when Iraq's invasion of Kuwait disrupted schedules around the region and left me with time to spare in a Cairo unusually free of tourists.

The choice of subjects is subjective and random. The sketches were never meant to be a comprehensive presentation of Cairene architecture; they merely reflect the itineraries of my walks, recording whatever attracted my attention. Similarly, the accompanying lines of text are not a systematic description. They simply relate what I have found amazing to learn about the city, its buildings, and its people.

Preface

For those completely unfamiliar with Egypt and Islamic culture, some basic facts and terms are explained in a glossary at the end of the book. For orientation, a map indicates all of the locations portrayed in the drawings. This collection of sketches, however, is not intended to be a substitute for a history textbook and it certainly is not a guidebook. It is just my grateful personal tribute to Cairo, the Mother of the World, presented here in hopes of sharing some of the enriching experience that this unique and fascinating city can offer.

Acknowledgments

All one needs to make a line drawing are a sheet of paper, a pen, and some ink. To turn a stack of drawings into a book is an altogether different matter. This requires a collaborative effort of many people. The folks at the American University in Cairo Press made it happen: Mark Linz, Pauline Wickham, Neil Hewison, Andrea El-Akshar, and others. In writing the text, I am indebted to too many people to name them all, but the friendly advice of Susan and Sheldon Watts was especially important. Wilson Edgar of W©Image Co. was helpful in making the print-ready copies of the drawings, as was Arco Iris Co., both in Lisbon, Portugal.

But first of all, this book would never come into existence without Professor Jason Thompson of the AUC. He convinced me to write it over a delicious dinner cooked by my wife Agnieszka, and this was just the beginning of her involvement so essential that she is in effect co-author of the book.

The Living Stones of Cairo

QARAFA AL-SHARQIYYA
FARAG IBN BARQUQ

The Mosque
of
Ahmad ibn Tulun – Interior

DATE: 876–79
INDEX NO.: 220
LOCATION: D-5: *Qal'at al-Kabsh, next to Saliba Street*

The Mosque of Ahmad ibn Tulun: Outer Wall and Minaret, page 4

Al-Azhar Mosque, a later congregational mosque, page 6

The Egyptians have raised monumental buildings in stone for millennia, and the skill did not vanish after the Arab conquest: the oldest surviving Islamic monument in Cairo, the Nilometer, is expertly built in cut stone. Its pointed arches predate those in Europe by several hundred years.

Yet the first sovereign ruler of Islamic Egypt, Ahmad ibn Tulun, chose to build a great congregational mosque in brick, not stone. The mosque was constructed to serve a new urban unit laid out beyond the crowded earlier capital, al-Fustat, which already had its own congregational mosque. The pattern of adding new extensions to the city was to be repeated, and still more grand courtyard mosques were built. Today, the site of al-Fustat is an empty field of ruins, and has been for more than eight hundred years. Nothing of Ibn Tulun's city remains either, but his mosque still stands.

Typical of Muslim architecture, the mosque displays the beauty of its exquisitely proportioned arcades before the immense internal courtyard, with little regard for the external façades. The perfect, dignified proportions of its arches and pillars and the studied simplicity of design bring the enormous structure down to a human scale, as good architecture always does. Looking at the sun-drenched courtyard, one easily forgets that it is half again as large as a football field. Around the courtyard, multiple rows of arcades on massive square pillars, with no internal divisions, offer unbroken views of majestic perspectives. Nothing detracts the eye from the pure geometry of the architecture. Although the decoration is subordinate to architectural divisions, there is some exquisitely cut stucco, including ornamental window grilles of gypsum and stained glass—fragile pieces that have remarkably survived for more than a thousand years.

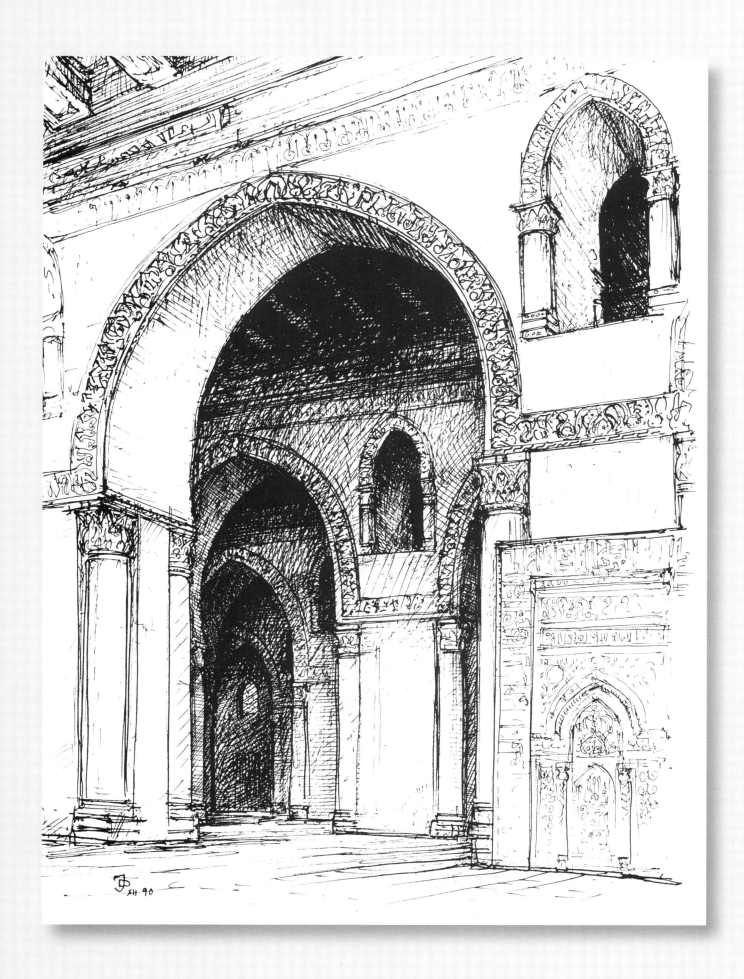

The Mosque
of
Ahmad ibn Tulun – Outer Wall and Minaret

DATE: 876–79
INDEX NO.: 220
LOCATION: D-5: *Qal'at al-Kabsh, next to Saliba Street*

*Caliph al-Hakim and
his mosque, page 12*

egend has it that Ahmad ibn Tulun's architect, a Christian, declared that he could build a mosque without using stone, for he wished to spare Christian churches, from which marble columns would otherwise be taken. This is why the structure is built entirely of bricks. There are more legends surrounding the mosque, its site, and its founder. Many were recorded in the 1930s in a book by Major Gayer-Anderson, an Englishman whose house next to the mosque has been turned into a museum, and whose grandson now conserves stone architecture in Cairo. In reality, Ahmad ibn Tulun had other reasons when he chose the shape and material of his mosque. He proclaimed himself a suzerain, and for him the notion of royalty meant to emulate the caliph, who had just moved his capital in Iraq to Samarra. There the caliph had built a grand brick mosque, which Ibn Tulun strove to imitate.

One of the features that the mosque in Cairo shares with the one in Samarra is its distinctive minaret with an external spiral staircase. The structure is quite mysterious. Unlike the rest of the mosque, it is faced entirely with stone, and the date of its construction is a great puzzle to scholars. It is known only that the top story was built after the great earthquake of 1303 by Lagin, the same sultan who added new tops to the minarets of al-Hakim.

What can be seen from the outside is not the wall of the mosque, but an enclosure that separates the mosque from the bustle of the surrounding streets and markets. A small medieval European walled city with its market square, city hall, and parish church could easily fit within the mosque's precinct. The comparison is not altogether improper, because a congregational mosque like this was meant to accommodate the entire Muslim population of the city it served.

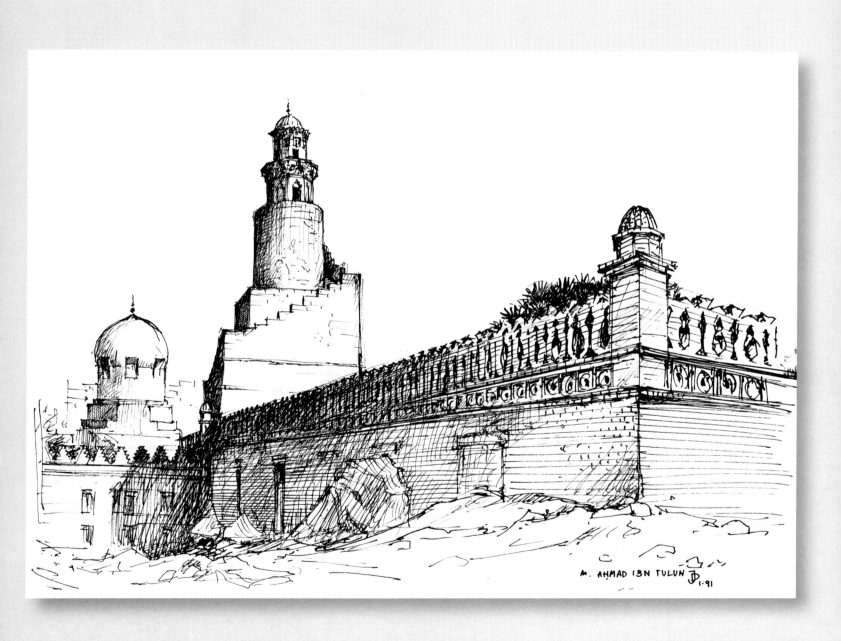

M. AHMAD IBN TULUN
1-91

Courtyard
of
al-Azhar Mosque

DATE: 972; 15TH–16TH CENTURIES (MINARETS)
INDEX NO.: 97
LOCATION: E-3: *al-Azhar Street, next to al-Husayn Square*

The Mosque of Ahmad ibn Tulun, pages 2,4

Northern Walls of Cairo, page 12, Bab Zuwayla, pages 8, 10

When the Arab armies were swiftly incorporating vast territories into the young Islamic Empire, the conquerors typically established their military settlements outside of existing cities. Each new settlement would have a congregational mosque, where the entire Muslim community gathered for Friday prayers. The architecture was plain. The early Muslims remembered well the pure simplicity of the first mosque, the courtyard of the Prophet's house.

The pattern of Muslim rulers establishing new capitals apart from earlier cities persisted, and Cairo was no exception. When the Fatimids of North Africa conquered Egypt in 969, they built their own walled royal city, with al-Azhar as its congregational mosque. By that time, the architecture had become ornate and elaborate, but the basic principle remained: a square courtyard surrounded by arcades. The arcades, supported on columns retrieved from ruined ancient buildings, provided shade for the faithful coming to pray, but also for those who came seeking knowledge. Al-Azhar was a center of learning, arguably the world's oldest university. Originally spreading the Shiite doctrine, it remained a teaching institution after Egypt returned to Sunni Islam, and still is today.

A recent restoration left the external stone façades (mostly Ottoman and nineteenth century) shining clean, but also obliterated some original Fatimid decoration. This work is only the last in a long succession of rebuilding and additions that began just ten years after the first construction, leaving little of the original structure in place. Subsequent rulers adorned the mosque by adding colleges, arcades, gates, and minarets. The diverse minarets and domes added in Mamluk times resulted in a picturesque, almost fairy-tale silhouette, but the sun-swept central courtyard retains the simple noble splendor of the original.

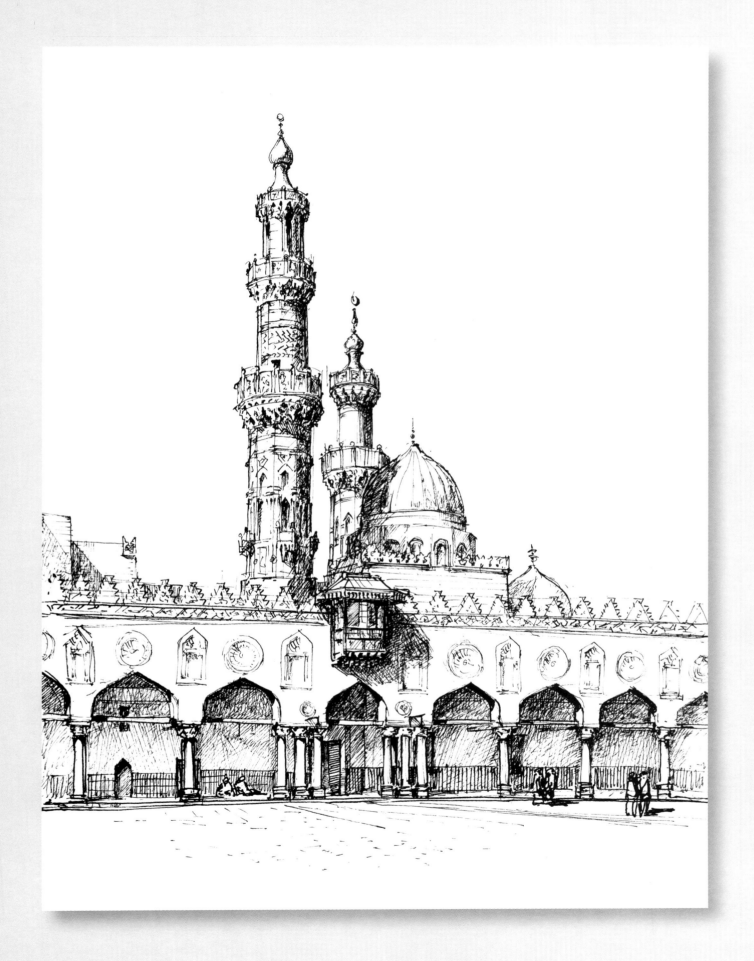

Bab Zuwayla – Detail

DATE:	1092
INDEX NO.:	199
LOCATION:	D-3: *on al-Darb al-Ahmar (Ahmad Mahir) Street, at the southern end of al-Muʻizz li-Din Allah Street*

The Mosque of Ahmad ibn Tulun, page 4

By the tenth century, three hundred years after the Prophet Muhammad, the Muslim community was much changed from the young, vast empire of the first caliphs. Deep strife divided the contenders to the leadership of Islam; local rulers reigned as independent suzerains. In Egypt, independent dynasties at times replaced the caliph's governors. In present-day Tunisia grew a Shiite religious movement, the Fatimids. Only after their army conquered Egypt in 969 could they seriously contest the orthodox caliph of Baghdad and claim the leadership of all of Islam. The Fatimid caliph entered his freshly established Egyptian capital, al-Qahira, in the month of Ramadan, in the year 971. His night-time ingress into the brightly lit city still resounds in the popular tradition, as thousands of colorful lanterns are sold next to the city gate of Bab Zuwayla every Ramadan.

What began in the North African desert as a religious movement grew in Cairo into imperial authority, sophisticated refinement, and incredible wealth. The Fatimid power did not last: in 1171 Salah al-Din (Saladin) put an end to the dynasty, which had long since degenerated into impotence. Nothing remains of the luxurious palaces, pleasure pavilions, and fabulous gardens that the Fatimids built in their royal enclosure of al-Qahira, but the formidable gates of the city stand in testimony to the dynasty's might. Bab Zuwayla still overwhelms with the sheer size of its massive walls of giant limestone blocks, some of them reused from ruined pharaonic structures. Even though the rising street level has long since buried the gate's feet deep in the ground, it still looms high over the neighborhood.

The Fatimid gates of al-Qahira were utilitarian, military structures. But even here, on the solid, austere masonry of the stone walls, gracious curves of ornamented niches, medallions, and moldings bring solid stone alive with a reflection of human imagination.

Bab Zuwayla

DATE: 1092
INDEX No.: 199
LOCATION: D-3: *on al-Darb al-Ahmar (Ahmad Mahir) Street,
at the southern end of al-Mu'izz li-Din Allah Street*

To look at the city gate of Bab Zuwayla and its surroundings is to see the whole history of Cairo probably better than anywhere else in the city. Power and majesty, poverty and misfortune, wealth as well as desolation, changing fortunes, empires come and gone—all have left their mark here. The enormous stone mass of the gate looms silently over a crowd of people at its feet. The crowd mills around, usually trying to make ends meet with a business worth pennies, sometimes busy making fortunes; a crowd always eager to watch any extraordinary event that comes along, be it a neighborhood quarrel or a state visit. Battered buses and shiny expensive cars have replaced pack animals and caparisoned stallions; otherwise the scene has not changed for centuries. This is perhaps the only location in the world that has never ceased to bustle with activity, twenty-four hours a day, for the past thousand years.

The crowd here has never lacked for extraordinary events at which to marvel. Rulers passed in ceremonial processions, saluted from the gate by an orchestra; rebellious chiefs were paraded in chains; the precious cover of the holy shrine of the Ka'ba was dispatched this way to Mecca every year. The rich and the powerful embellished the area with sumptuous buildings, and between 1415 and 1420 Sultan al-Mu'ayyad Shaykh even built a pair of ornate minarets on the tops of the gate's two semicircular towers. Bab Zuwayla was an ill-famed place too, where executions were held. The sensation-hungry crowd could see severed heads and hanged and crucified bodies displayed on the gate.

Bab Zuwayla was one of the massive stone gates of al-Qahira. The name, from which 'Cairo' derives, applies today to the entire metropolis. When it was founded, al-Qahira was an extension of the city that had existed for more than three centuries. The palatial enclosure housed the Fatimid ruler, his court, and his guards, not unlike the Forbidden City of Beijing or Moscow's Kremlin. Bab Zuwayla, along with al-Qahira's other gates and towers, some of which still stand, was a forceful statement of power and authority, expressed in stone. This was the work of Badr al-Gamali, an Armenian *wazir* to the Fatimid caliph. It is not surprising in Cairo, where all things seem to have secret meanings, and where even the distant past is always close behind, that the architect working nine hundred years later on the conservation of the gate is Armenian too.

*Sultan al-Mu'ayyad
Shaykh and his
mosque, page 42*

*Northern Walls of
Cairo, page 12*

10

Northern Walls *of* Cairo
and the Minaret of the
Mosque *of* al-Hakim

DATE:	990–1013 (MOSQUE); 1087 (WALLS)
INDEX NO.:	15, 7, 352
LOCATION:	E-2: *north of al-Gamaliya, along the modern Baghala/Galal Street*

The Fatimids, see:
Bab Zuwayla, page 8

A thousand years after his lifetime, the personality of the Fatimid caliph al-Hakim bi Amrillah continues to puzzle and confuse. Did his unpredictable acts of violence and inexplicable rulings result from a mental disorder, as has often been suggested? Was he a visionary religious reformer intent on purging his divinely guided empire of anything that he thought could corrupt it? Or, brought up in the luxury of the imperial palace, was he simply an eccentric individual, ordering at his whim executions and seizures, capriciously introducing and then revoking such decrees as a ban on playing chess? Perhaps he was a bit of all of these things, because in Cairo everything has always been stranger and more complex than it first appears.

The minaret of al-Hakim's giant mosque—with the domed top added in the later Middle Ages—springs from a massive buttress and peeks from behind the formidable stone walls of Cairo. Ten years after the two elegant, slender minarets were constructed, al-Hakim ordered them encased within enormous stone buttresses—not entirely, though, for the original shafts stand in well-like hollows in the later masonry. Whatever the reason for this strange arrangement, it seems in line with the caliph's erratic mind. The mosque's later history is no less peculiar. At one time, when Crusader prisoners were held here, it even housed a Christian chapel.

When it was built, the mosque stood outside the original mud-brick ramparts of the city. A century later, magnificent stone walls were constructed, and they enclosed al-Hakim's structure within them. The towers, gates, covered galleries, and crenellated bulwarks are masterpieces of medieval military architecture unparalleled in contemporary Europe. In line with the paradoxical nature of Cairo, they were never besieged.

Today, as it has been since time immemorial, the area around the noble mosque and the awesome gate of Bab al-Futuh nearby is a busy venue for wholesale trade in onions and garlic. Everybody knows that this is the place to go if one wants a bargain on a crate of onions. In Cairo, everything has always been simpler and more obvious than it first appears.

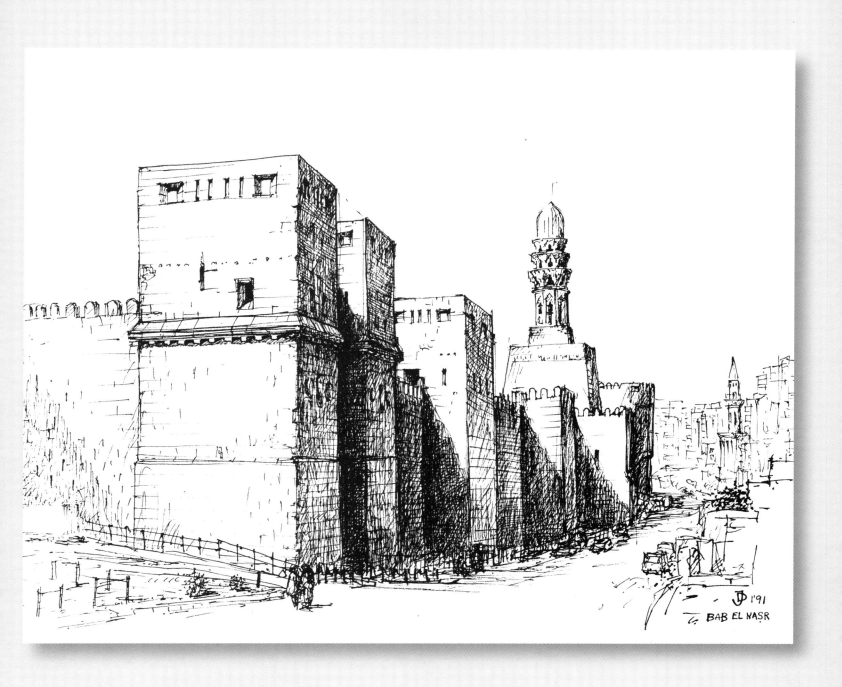

BAB EL NASR

Mashhad al-Guyushi
on the
Cliff of the Muqattam Hills

DATE: 1085

INDEX NO.: 304

LOCATION: F-5: *on top of the Muqattam Hills, overlooking the Citadel and the medieval city*

The Fatimid Northern Walls of Cairo, page 12 Bab Zuwayla, page 10

A *mashhad* is a shrine or commemorative mosque, where prayers can be said next to a tomb of a saintly or important person. A number of *mashhad*s were built in Egypt under the Fatimids (tenth–twelfth centuries). These small and unpretentious structures are captivating works of architecture, and the way they they combine open spaces with semi-open and enclosed areas continues to inspire award-winning modern designs. The structure built on the flat top of the Muqattam range, adorned inside with exquisite carved stucco, was meant to be more than just a place of worship and meditation. It was erected as a monument to the memory of the remarkable man who founded it, the Fatimid-era *wazir* Badr al-Gamali, the Armenian to whom Cairo owes its magnificent stone ramparts and gates. The *wazir* was never buried in the mausoleum that bears his name, but the massively built structure also had another purpose. From its hilltop location, commanding views over all Cairo, Giza, and the approaches, any movement of an attacking army could be spotted and reported by a signal from the minaret to the guards on the city gates.

The limestone beds of Muqattam, deposited on what was a sea floor some forty million years ago, were Cairo's main sources of building stone. For hundreds of years they have been quarried and cut into standard-sized blocks for countless mosques, houses, and palaces. The vertical cliffs of the massive quarries now provide a dramatic backdrop for the minarets and domes of the Eastern and Southern Cemeteries. In the Middle Ages and in Ottoman times, the desert hills could be a dangerous place. Bedouin tribes marauding in the area extorted protection money in exchange for the safety of the caravans transporting stone. Mamluk sultans regularly paid the Bedouins off. There are no marauding robbers any more, but even today the area beneath the hills has not been built up and incorporated into the nearby city.

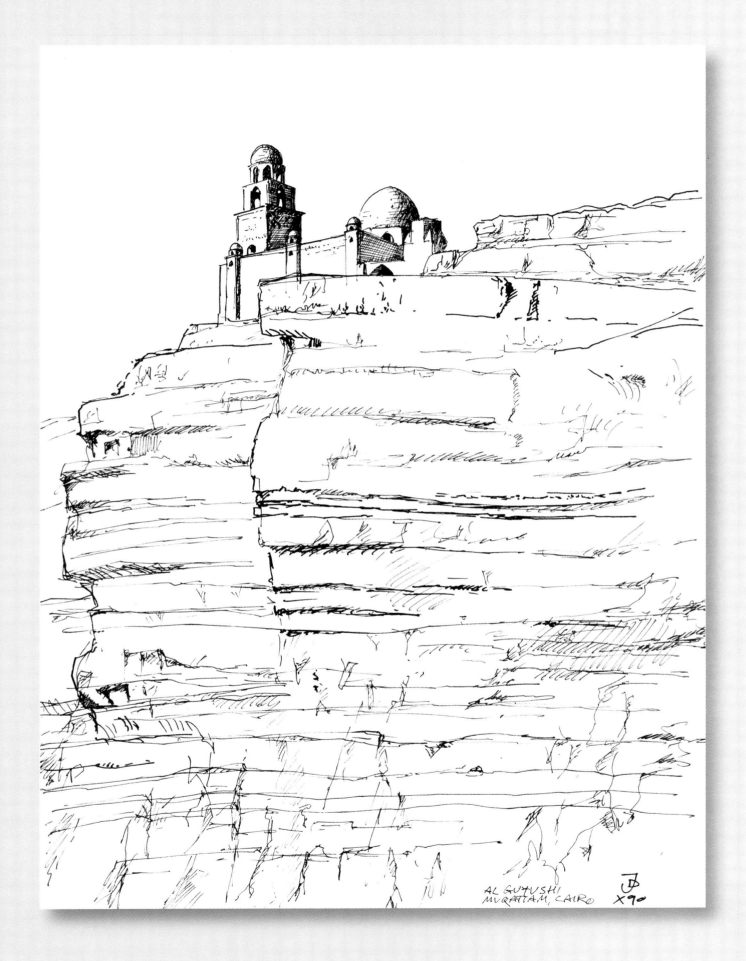

AL GUYUSHI
MUQATTAM, CAIRO

The Mosque
of
al-Salih Tala'i'

DATE: 1160
INDEX NO.: 116
LOCATION: D-3: *al-Darb al-Ahmar (Ahmad Mahir) Street, in front of Bab Zuwayla*

Bab Zuwayla,
pages 8, 10

16

Conservation work
in Cairo, see page 50

Few buildings in Cairo have gone through as many changing fortunes as the Mosque of al-Salih Tala'i', next to the great gate of Bab Zuwayla. The gate was built by an Armenian *wazir* brought to Cairo to restore order in a calamitous time. One hundred and seventy years later, another Armenian, al-Salih Tala'i' ibn Ruzziq, was summoned from Upper Egypt, where he had been a governor, to put an end to yet another bloody turmoil in the capital. He succeeded in restoring peace, but six years later a conspiring princess poisoned him. Before he died, he had his assassin executed in front of him.

The balanced beauty of the mosque does not betray the underlying violence and passion. The building, in the form of a courtyard surrounded by arcades, was embellished with intricately carved stucco and wood (some of which has survived) and a variety of ancient marble columns. But by the Middle Ages the mosque had already suffered from earthquake damage, neglect, and disrepair, and had been repaired and rebuilt a number of times. By the late nineteenth century, it had been changed beyond recognition, with its lower floor buried deep in the ground, and the rest hidden under encroaching buildings. Only the colonnaded arcade of the sanctuary continued to be used as a mosque. A massive restoration began in 1896 and lasted for decades. It attempted to take the mosque back to its Fatimid stage, but changed many original features and obliterated evidence of later medieval and Ottoman history. The ground floor was excavated and exposed, but when the groundwater level rose dramatically in the 1970s, it was flooded. For over twenty years the building sat in foul wastewater, until a sophisticated groundwater control project in 1998 drained the area around it.

Throughout all the changes, the mosque has remained an oasis of tranquillity in the bustling neighborhood, the noble proportions of its arcades and the intricate patterns of its decoration oblivious to changing fortunes. It is a living part of the community life too. In the afternoons, young boys sit around the marble columns of its arcades to receive religious instruction, just as their ancestors did in the Middle Ages.

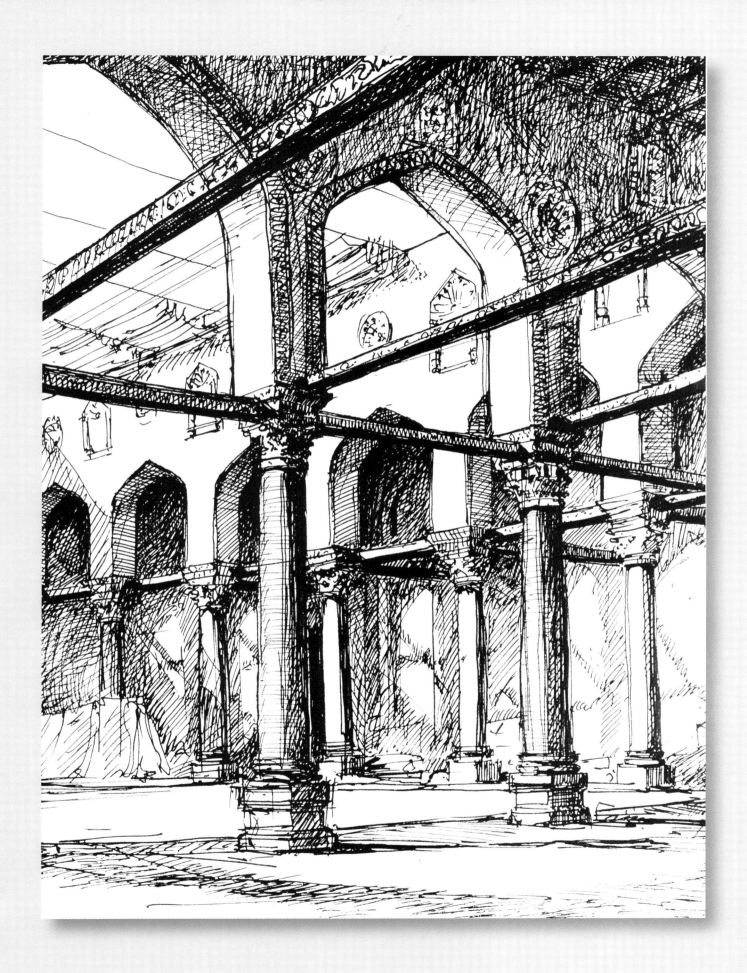

The Madrasa
of
Sultan Qalawun – Courtyard Façade

DATE: 1284–85
INDEX NO.: 43
LOCATION: D-2: *Bayn al-Qasrayn, on al-Mu'izz li-Din Allah Street*

*T*he climate of the Middle East generously afforded Islamic architecture what is probably its biggest asset: the refined interplay of interior, open, and semi-enclosed spaces. A grand, richly decorated façade separates the sanctuary of Sultan al-Mansur Qalawun's mosque from the courtyard, but it is merely a screen made up of multiple open arches.

Behind it, rows of granite columns divide the space into aisles, as in a basilican church. Sultan Qalawun spent much of his life in Syria and Palestine fighting the Crusaders, so he was familiar with the monumental stone architecture there. Was it an inspiration for his own grand project? We may only speculate, but the idea seems plausible.

Like all Mamluks, Qalawun, a Kipchak Turk, was brought to Cairo as a young slave, then received military training and eventually personal freedom from his master. From the slave troops of *mamluk*s came the ruling elite of the country, including the most powerful amirs, who chose the sultan from among themselves. Qalawun's first master, Aqsunqur (whose mosque still stands in al-Darb al-Ahmar) bought him for the unusually high price of one thousand dinars. Qalawun took pride in it; even when he became a sultan, he kept 'al-Alfi' (from Arabic *alf*, one thousand) as one of his royal titles.

Qalawun's descendants: see al-Nasir Muhammad, pages 22, 24, and Madrasa of Ilgay al-Yusufi, page 34

Before he rose to the throne, he was a loyal ally to his onetime mate from the army barracks, Sultan Baybars, who emerged as a ruler after the turbulent takeover of power from the Ayyubid dynasty and became the founder of the powerful Mamluk state. When Baybars died in 1277, his successor tried to get rid of Qalawun by sending him on faraway expeditions, but Qalawun was not to be disposed of easily. In 1280, he returned at the head of an army and deposed and exiled the sultan, replacing him with a seven-year-old boy. Qalawun took control of the state as *atabak*, or the chief army commander. It was only three months before he shook off all pretenses, deposed the child, and assumed the sultanate himself. He proved to be a capable ruler, successfully fighting the Mongols and the Crusaders and founding a dynasty that lasted for a hundred years.

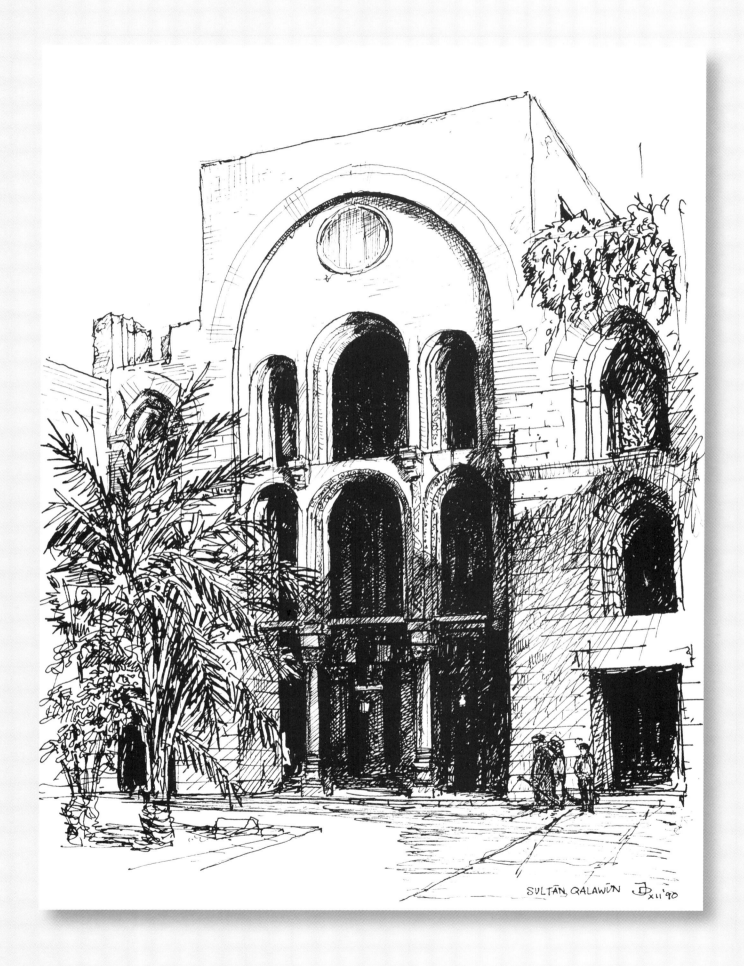

SULTĀN QALAWŪN

View of the Mausoleum
of
Sultan Qalawun – from Bayt al-Qadi Street

DATE: 1284–85
INDEX NO.: 43
LOCATION: D-2: *Bayn al-Qasrayn, on al-Mu'izz li-Din Allah Street*

Interior decoration: see the Mosque of Sultan al-Ashraf Barsbay, page 48

Endowment (waqf) system: see Sabil–Kuttab Ruqaya Dudu, page 82

20

"When a spectator contemplates this huge edifice and hears that it was built in such a short time, he often will not believe it." These words are as true today as they were when a chronicler wrote them six hundreds years ago. It is indeed hard to believe that it took only fourteen months to erect the massive walls, giant columns, and lofty arches and domes of this enormous complex, which consists of a mosque with teaching facilities, a monumental mausoleum, and a great charity hospital—and to embellish it all with panels of multicolored marble and mother-of-pearl, with exquisitely carved stucco, wood, and stone, with gilding and painting. The mosque and the tomb continue to amaze with their grand scale and beauty of decoration, even though time has taken a heavy toll on them. The original buildings of the hospital are almost completely gone, but the site is still used by an ophthalmology clinic. It has kept its designated function since 1280, more than seven hundred years. When it was founded, the hospital was a marvel of its day, with separate wards for different diseases, and with a generous endowment that paid for a highly qualified medical staff, for maintenance of the facility, and even for musicians and storytellers to entertain the patients.

The huge dome, grand façade, and minaret of Sultan Qalawun's complex were meant to impress, but they could not be seen as they are today: narrow lanes of the medieval city did not offer grand panoramic views. The wide street joining the complex to Midan Bayt al-Qadi (the Square of the Judge's House) was cut through city blocks only in the early twentieth century. In Cairo, different trades tend to have their distinct areas. This particular street deals with every sort of scale, from apothecaries' precision instruments to those used to weigh bales of cotton.

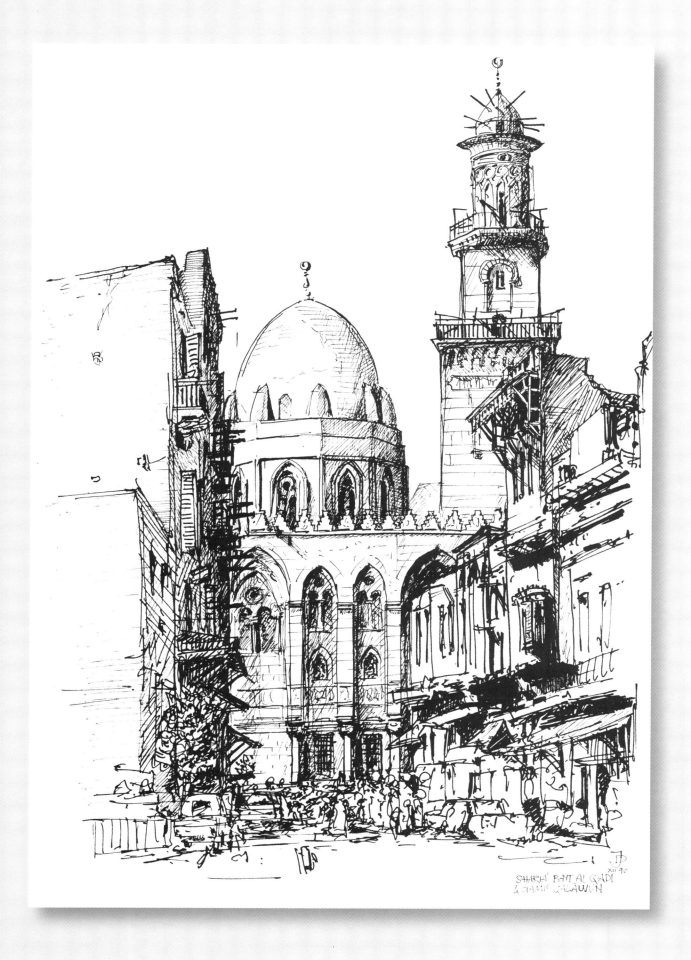

SHARIA BAYT AL QADI
& GAMI QALAWUN

The Minarets *of* Sultan
Qalawun and his son
al-Nasir Muhammad

DATE: 1285 (QALAWUN), 1295–1304 (AL-NASIR)
INDEX NO.: 43, 44
LOCATION: D-2: *Bayn al-Qasrayn, on al-Mu'izz li-Din Allah Street*

*T*o enter the courtyard of al-Nasir Muhammad's *madrasa*, one passes under the pointed arch of a Gothic marble portal, rather unusual for Cairo. It was brought as a war trophy from a church in Acre after the last remnants of the Crusader states in Palestine were crushed by the Mamluk sultans. Time has taken a heavy toll on the *madrasa*, but its courtyard offers an imposing view of two grand minarets—as can be expected in Cairo, which is justly called the city of a thousand minarets. These two, built by al-Nasir Muhammad and his father Qalawun, have lost their original tops, but even so disfigured they are still admirable. Just one generation apart, their styles are distinctly different. Qalawun's, built of stone, displays bold lines of restrained, powerful architectural forms. His son's, made of bricks, is covered with stucco richly carved in delicate lace-like patterns. The style of late Mamluk stone buildings, the crowning achievement in Cairo's architecture, is in many ways a combination of the two minarets' characteristics.

Sultan Qalawun, page 18

Sultan al-Nasir Muhammad, page 24

Sultan Barquq, page 38

They were built by father and son, both sultans of Egypt and both remarkable statesmen. Although the offspring of the *mamluk*s who formed the ruling elite were not normally allowed to follow the military career of their fathers, al-Nasir Muhammad succeeded Qalawun on the throne. Deposed twice, he not only managed to stay in power, but within twenty-one years of his death eight of his sons had become sultans. Most of them were mere figureheads for feuding Mamluk factions, but some of their progeny ascended to the throne too. Afterward, power shifted to Circassian, rather than Turkish, Mamluks. The first Circassian sultan, Barquq, decided to leave his mark on the city by building a *madrasa* immediately next to these of al-Nasir Muhammad and his father.

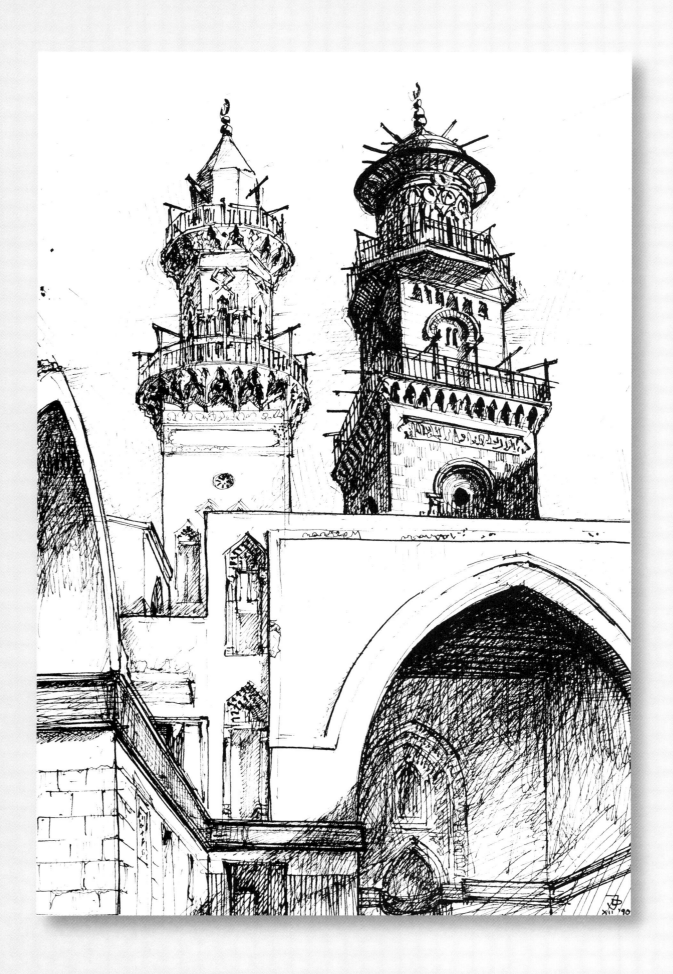

Khanqah
of
Sultan Baybars II al-Gashankir

DATE: 1306–9
INDEX NO.: 32
LOCATION: E-2: *al-Gamaliya Street*

Sultan al-Mansur Qalawun, page 18

The Mosque of Ahmad ibn Tulun, with restorations by Sultan Lagin, page 4

The Madrasa of al-Nasir Muhammad, page 22

The Khanqah of Sultan Baybars al-Gashankir was the first convent for a brotherhood of Sufi mystics built in Egypt. It was distinguished in the Middle Ages by the prominent scholars appointed as its directors. The Sufis, who lived in the rows of rooms arranged in four stories around the spacious courtyard and recited prayers over the founder's tomb, were guided by such memorable figures as the famous historian, geographer, and philosopher Ibn Khaldun. The beginnings of this venerable institution, however, were marked by human passions very different from scholarly pursuits: lust for power, betrayal, and revenge.

Initially a *mamluk* of Sultan al-Mansur Qalawun, Baybars became entangled in the power struggle after the ruler's death. He was promoted by Qalawun's young son, al-Nasir Muhammad, but later served the man who deposed the boy. This sultan abdicated. The next one on the throne, Lagin, was soon assassinated, and the fourteen-year-old al-Nasir Muhammad was reinstated. Baybars assumed the position of the *atabak*, the commander of the army. He posed as the protector of the young sultan, but in reality, together with the boy's regent, denied him not only any real power, but even basic necessities. Baybars now had the resources to build the *khanqah* acclaimed by the fifteenth-century chronicler al-Maqrizi as the most sumptuous in Egypt and to attach to it a huge domed mausoleum for himself. In 1310, al-Nasir Muhammad escaped to Syria. Baybars dropped all pretenses and assumed the sultanate, but only managed to rule for a year. When the young exile returned to take the throne for the third time, he was bound to hold onto power with all his strength. Baybars was soon arrested, flogged, and strangled. Al-Nasir Muhammad not only ordered his onetime oppressor's *khanqah* closed, but also erased his name from the building. The chiseled-out spaces can still be seen on the bands of calligraphy that adorn the magnificent black-and-white marble portal. Only after some time was the angry sultan persuaded to let the body of Baybars be interred in his mausoleum, and the *khanqah* reopened after a few years.

Al-Gamaliya Street, on which the building stands, doubled the spine of the city. When no room was left on the main street, the Qasaba (now al-Mu'izz li-Din Allah Street), large commercial establishments were built along al-Gamaliya Street. The lavishly decorated stone gate next to the *khanqah* of Baybars belonged to an Ottoman-era *wikala*.

M. BAYBARS, GAMALIYA

The Madrasa
of
Sultan Barquq – Internal Courtyard

DATE: 1384–86
INDEX NO.: 187
LOCATION: D-3: *al-Gamaliya district, Bayn al-Qasrayn (al-Mu'izz li-Din Allah Street)*

Compare to the courtyard of the Madrasa of Ilgay al-Yusufi, page 32

Sultan Barquq, page 38

The door, clad with intricate patterns in cast bronze, accentuated with a marble-inlaid portal, and set within a powerfully expressive architectural frame, marks a corner of the courtyard in the Madrasa of Sultan Barquq. On the four sides of the sunlight-flooded courtyard, four lofty arches open into spacious shaded recesses, or *liwan*s. This is the general design of a Mamluk *madrasa* in Cairo, no matter how much the details may differ. The central space is a cross formed by the courtyard and the four *liwan*s (hence, such buildings are called cruciform *madrasa*s). The corner spaces between the arms of the cross were filled with subsidiary and service rooms on multiple stories. A door in each corner of the courtyard led to teachers' apartments, students' rooms, ablution areas and bathrooms, an elementary school, storerooms for lamp oil and incense, and the founder's tomb, where Sufis continuously prayed and recited the Quran.

These buildings were not meant to be lifeless memorials to their founders' glory; they were designed to be a functioning part of the living city, and they were busy with different activities. The Madrasa of Sultan Barquq, with its attached residential units, provided permanent dwellings for 205 students and Sufis.

The streets of Cairo today are as crowded and busy as they were in the Middle Ages, but the city's historic buildings are empty. The *madrasa*s are no longer teaching institutions, the *sabil*s do not offer water to people on the streets, and Sufis no longer recite over sultans' tombs. In the enormous Madrasa of Sultan Barquq, a handful of people gather for prayer, then they depart, leaving the vast courtyard to the dozing watchman, to some occasionally passing birds, to wandering cats.

Sabil
Shaykhu

DATE: 1345
INDEX NO.: 144
LOCATION: E-4: *Bab al-Wazir Street, in Bab al-Wazir Cemetery*

28

*Sabil–Kuttab Ruqaya
Dudu, page 82*
Sabil Qitasbay, page 76

*Sultan al-Nasir
Muhammad,
pages 22, 24*
*Sultan Hasan and his
mosque, page 44*

Cairo has plenty of *sabil*s, or water fountains, but this one is unique. Usually, the *sabil* was built over an underground cistern, but in this case, the *sabil* room was cut into the bedrock, apparently making use of a cave with a natural spring. The semi-dome that ingeniously completes the rock is also unique to this *sabil*. Other buildings founded by Amir Shaykhu were also unusual, such as the double complex of a mosque and a school on either side of Saliba Street, with minarets positioned to frame the street view. This was an early example of architectural design focusing on the urban landscape rather than on particular buildings, a very innovative idea in its time.

The unconventional architecture seems to reflect the personality of the amir, apparently a man of strong character. He started his career during the long reign of al-Nasir Muhammad. He later held different offices for al-Nasir's son and successor, young Sultan Hasan. A faction of Mamluks led by Amir Taz (whose grand palace still stands in ruins next to Shaykhu's mosque) soon ousted Hasan and placed the deposed sultan's younger brother on the throne. Shaykhu lay low for three years. It was during this time that he built the *sabil*, which bears the insignia of the office he satisfied himself with at the time: the royal cupbearer. Then, when Taz was away hunting, he seized the puppet sultan and reinstated Hasan. As the sultan's protector and confidant, Shaykhu controlled the affairs of the state. He became the commander of the army, with the new title of 'the Great Amir.' His success, however, lasted only three years before he was murdered by royal Mamluks at a council meeting in 1357. Without this powerful ally, Sultan Hasan managed to survive for only four more years.

A monument to passing glory, the *sabil* itself is fading away, its decayed stone turning into powder.

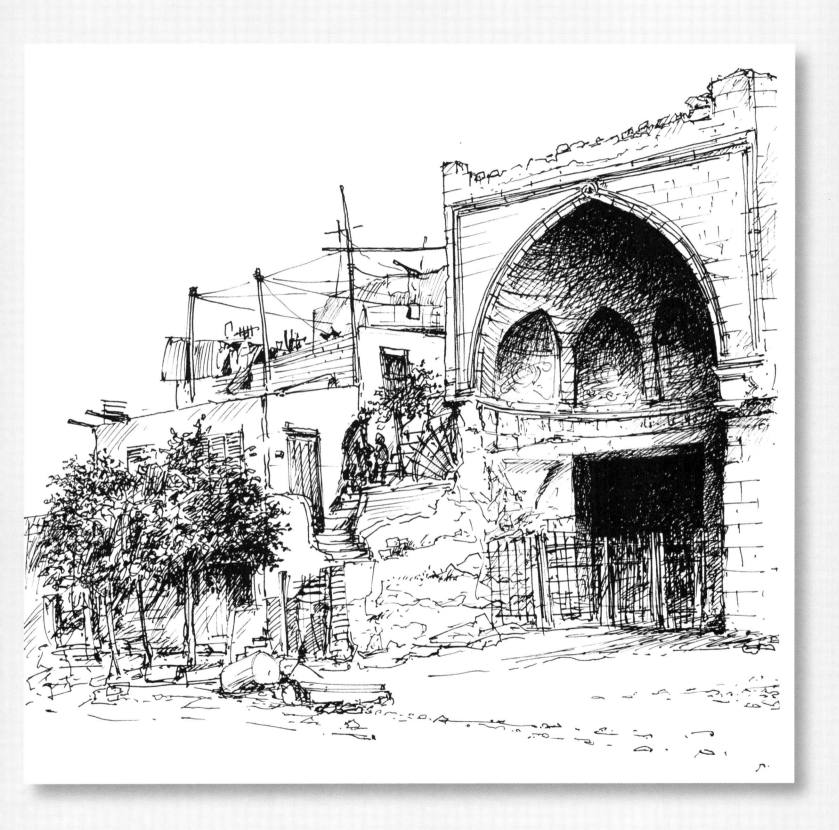

Portal
of the
Mosque of Shaykhu — the Muqarnas Hood

DATE: 1349
INDEX NO.: 147
LOCATION: D-4: *Saliba Street, between the Mosque of Sultan Hasan and the Mosque of Ahmad ibn Tulun*

A dome is a great solution for covering a square room. It has many advantages over any flat roofing. There is a drawback, however: the base of the dome is round. Over the corners of the square room, it would have to hang in the air. One simple answer to the problem is to build arches across the corners, which are thus turned into vaulted corner niches. Now the square is turned into an octagon. By building another row of niches above, it is possible to cut corners again, getting closer to the circular shape with each subsequent row of niches.

This was probably the origin of *muqarnas*, the decorative device of tiered ornamental niches so universally employed in Islamic architecture. Whether or not originally invented for structural purposes, the design is visually so attractive that even the earliest known examples (some from Cairo) are purely decorative. Once adopted as decoration, the *muqarnas* became a hallmark of Islamic art of all periods, from the mosques of Iran to the palaces of Granada. *Muqarnas* niches are found in interiors and externally, under corbelled balconies, below domes, in portal hoods, even in wooden ceilings and on furniture. In most of the Muslim world, they were usually made of stucco, but the builders in Cairo excelled in carving *muqarnas* in stone. Throughout the centuries, a façade with recesses covered with *muqarnas* work was a constant element of Cairene architecture. This portal of the mosque of Amir Shaykhu is just one of dozens still surviving in the city.

Amir Shaykhu and his other buildings in Cairo, page 28

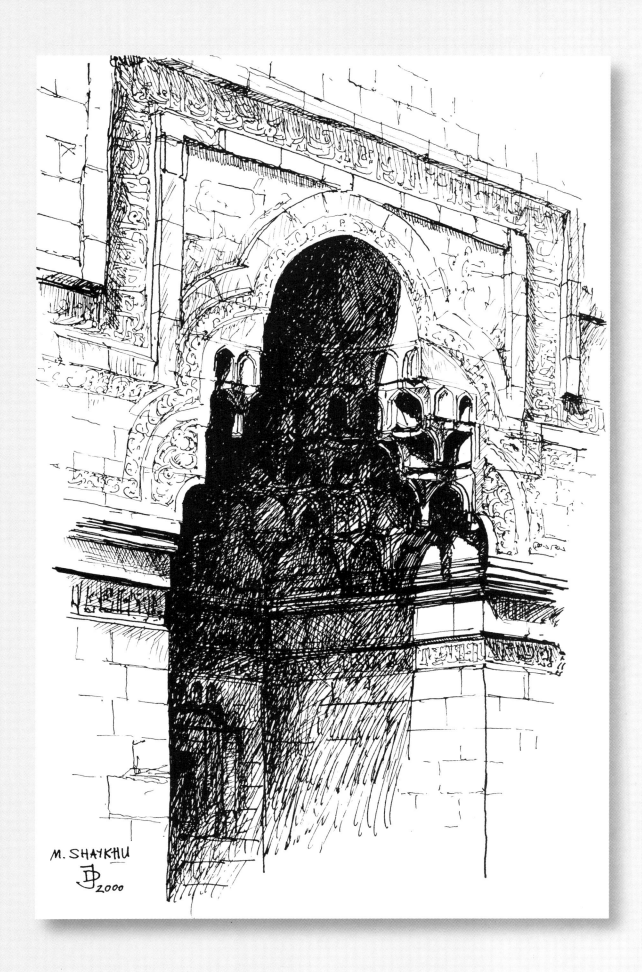

M. SHAYKHU
2000

The Madrasa
of
Ilgay al-Yusufi – Interior

DATE: 1373
INDEX NO.: 131
LOCATION: D-4: *Suq al-Silah Street, close to Muhammad 'Ali (al-Qal'a) Street*

The Fatimids: see Bab Zuwayla, page 8

Amir Ilgay al-Yusufi, page 34

In the peculiar structure of Mamluk society, the sons of the military elite were denied access to the caste of their fathers. They usually took civilian offices, and this required legal training. Perhaps this is the reason why *madrasas*, schools teaching Islamic law, were so numerous in medieval Cairo, and why they were the Mamluk amirs' favorite type of religious foundation.

Today, most medieval *madrasas* are used simply as neighborhood mosques. The distinction between buildings conceived as teaching institutions and those designed only for worship—which was always blurred—has been completely lost. *Madrasas* were first built in large numbers in Cairo when Salah al-Din (Saladin) put an end to the Fatimid dynasty, and after two hundred years of Shiite rule, Egypt reverted to orthodox Sunni Islam. The *liwan*s opening with lofty arches onto the sides of a central square courtyard served as classrooms for the four orthodox schools of Islamic law. In Mamluk times, this was the standard architectural type for a religious building in Cairo: a *madrasa* was used as a prayer hall as well as a school, and formed a center of a larger complex, with attached subsidiary charities, service rooms, and the domed tomb of the founder. The building erected on Suq al-Silah Street by Amir Ilgay al-Yusufi is a typical example.

By the late 1300s, the elements of such complexes—the courtyard *madrasa*, the entrance porch, the minaret, the *sabil–kuttab,* etc.—had evolved into fairly standardized forms. The ingenuity of architects was directed toward refining the proportions and decoration within endles combinations of essentially the same units. This approach may be alien to our modern taste, but it is not unlike that of classical Greece, where harmonious proportions and refinement of decoration were valued over innovation. Within the seemingly limited range of repetitive motifs, there was plenty of room for the creativity of architects and the mastery of craftsmen.

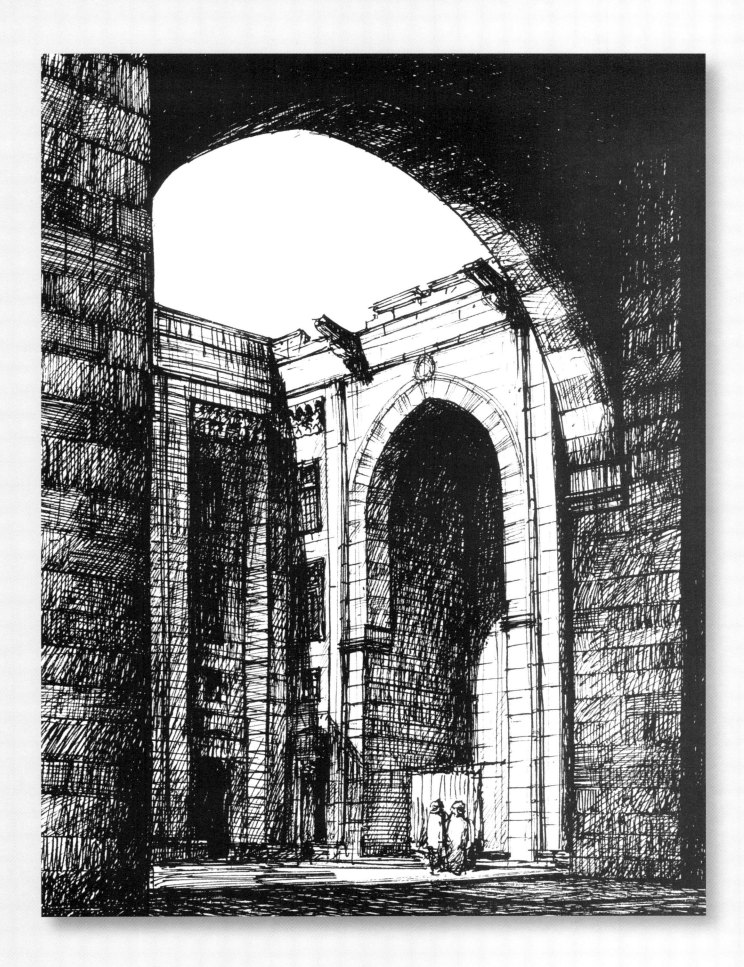

The Madrasa
of
Ilgay al-Yusufi on Suq al-Silah Street

DATE: 1373
INDEX NO.: 131
LOCATION: D-4: *Suq al-Silah Street, close to Muhammad 'Ali (al-Qal'a) Street*

The Mosque of Sultan Hasan, page 44

The Mosque al-Nasir Muhammad, page 22

The Madrasa of Sultan Sha'ban, page 36

Ilgay al-Yusufi, the commander of the army, decided to build his *madrasa* on Suq al-Silah Street. The reason for the choice seems evident. Suq al-Silah—the Market of Weapons—was important to the bellicose Mamluks; sumptuous buildings along its length attest to its importance in the Middle Ages. It is still teeming with people today, but fruits and vegetables have replaced the swords and daggers, and T-shirts the armor.

The street starts below the Citadel, next to the Mosque of Sultan Hasan, son of al-Nasir Muhammad. It runs past the *madrasa* of Qutlunbugha, one of the conspirators who brought Sultan Hasan down. On the same street is a gate built by Amir Mangak, who was a *mamluk* of al-Nasir Muhammad's father, and who outlived al-Nasir and all his reigning sons. Farther down stands the bathhouse of Bashtak, a trusted amir of al-Nasir Muhammad, executed by Qawsun, a confidant of al-Nasir's son and successor Abu Bakr. (Qawsun built another mosque nearby.)

Just as the buildings are linked by the network of streets and alleys of medieval Cairo, the life stories of people involved in the turbulent events of Mamluk history are intricately interwoven. The Market of Weapons joins al-Darb al-Ahmar Street next to the mosque founded by Baraka Khatun, the mother of Sultan Sha'ban. She was married to another son of al-Nasir Muhammad's. After the death of her husband, the immensely rich widow was wed to Ilgay al-Yusufi, the founder of the *madrasa* on Suq al-Silah. Before marrying the royal mother, whose ruling son was twenty years old by then, Ilgay had held different military offices under al-Nasir Muhammad's subsequently ruling sons, including the post of *jandar* ('wardrobe keeper') and *amir silah* ('controller of armaments'). Baraka Khatun died in 1373, the same year the *madrasa* was completed. Soon afterward, Ilgay drowned in the Nile. Apparently this was the result of his dispute with the royal Mamluks over his wife's treasures, rather than a mere accident.

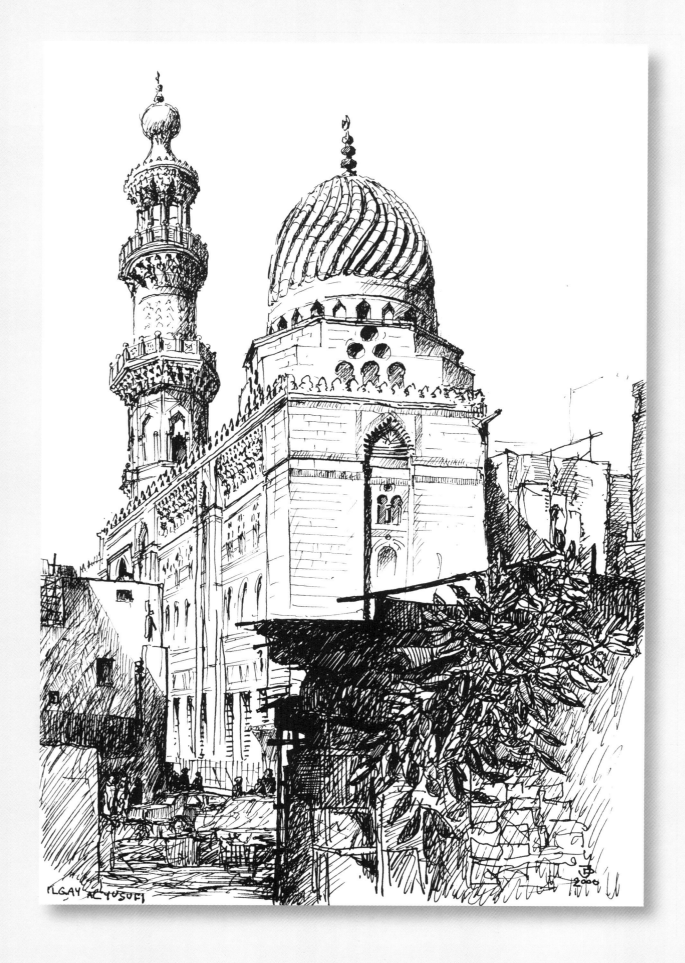

ILGAY AL YUSUFI

Al-Darb al-Ahmar Street — the Madrasa
of
Sultan Sha'ban

DATE: 1368–69
INDEX NO.: 125
LOCATION: D/E-4: *al-Darb al-Ahmar*

Compare to Amir Altinbugha al-Maridani, page 50, and Sultan Hasan, page 44

Cairo divided into local units: see Sa'd Allah Lane, page 92

Al-Qahira: see page 10, 80

House of Ahmad Katkhuda al-Razzaz, page 86

Sha'ban, a grandson of Sultan al-Nasir Muhammad, was elevated to the throne at the age of ten, to be strangled by his own *mamluk*s at twenty-three. He was not the only sultan who was never allowed to reach an old age; rather, it was exceptional for a member of the ruling elite to die in his bed. The building in al-Darb al-Ahmar was endowed by Sha'ban's mother, Princess Baraka, when he was still a boy; hence it is known as Madrasat Umm Sultan, the *madrasa* of the sultan's mother. Typically for Cairo, it was designed to be not only a place of prayer, but also a religious school, or *madrasa*. The faculty at the schools were sometimes renowned scholars from different parts of the Islamic world; Cairo has always been a powerful magnet. The rulers of the country were a military caste of Mamluks, brought to Egypt as slaves. Their sons rarely held military posts; instead, they prepared for civilian offices in these *madrasa*s. Their fates seldom come down to us in chronicles, as those of sultans and amirs do, but perhaps they lived longer.

Al-Darb al-Ahmar Street is called by different names along its route, and as often happens in Cairo, the official name does not always correspond to how it is locally known. This does not matter much in the city where people normally do not refer to places by street names, but by general localities: 'Sultan's Mother' is more meaningful than any name on a map. What matters more than a name is that this street runs from the Citadel toward al-Qahira's gate, Bab Zuwayla. Sultans would ceremonially descend from their palace at the Citadel on special occasions, greeted by fanfares played by orchestras along the way. A loggia for such an orchestra was attached to the *madrasa* of Umm Sultan Sha'ban. Numerous medieval mosques adorn the street, but of the Mamluk and Ottoman houses that gave it its character not so long ago, only a few remain. One of them is the sumptuous house of Ahmad Katkhuda al-Razzaz, the backdrop of this street view.

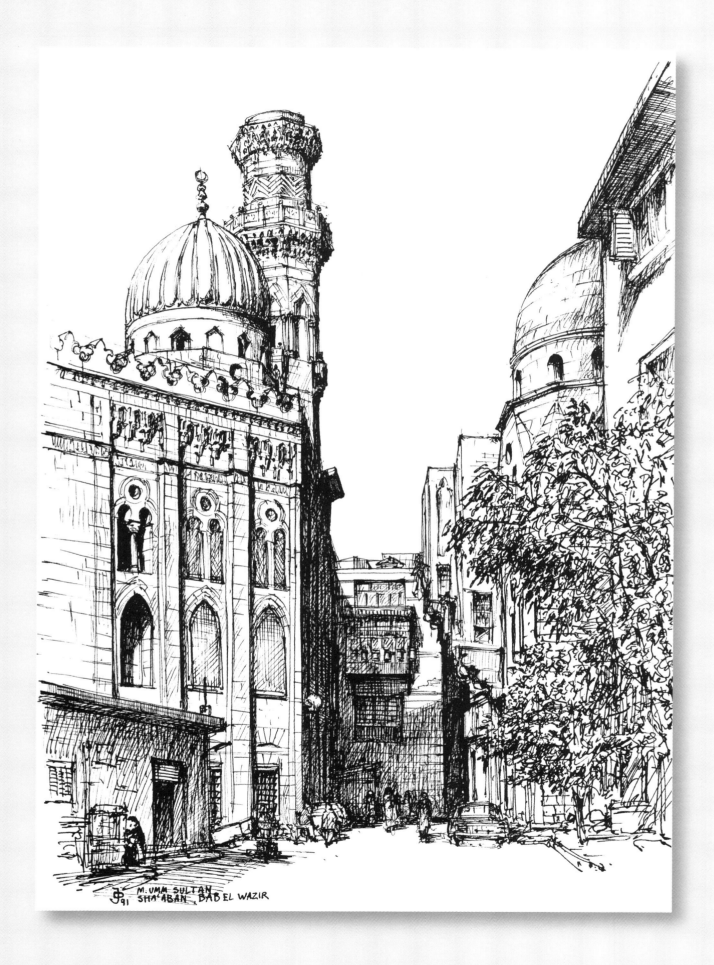

M. UMM SULTAN
SHA'ABAN BAB EL WAZIR

The Mosque
of
Sultan Barquq – Interior

DATE: 1384–86
INDEX No.: 187
LOCATION: D-2: *al-Gamaliya district, Bayn al-Qasrayn (al-Mu'izz li-Din Allah Street)*

Sultan Qalawun,
page 18

The man who supervised the construction of Sultan Barquq's mosque and *madrasa* at Bayn al-Qasrayn was called Jarkas al-Khalili. Many of the contemporary dignitaries fell into obscurity, but his name can still be heard in Cairo every day: he was the builder of Khan al-Khalili, the bazaar that is a must for every tourist.

Sultan Barquq was so pleased with al-Khalili's work at his mosque that when the building was completed in 1386 he rewarded everyone involved in the project with two gold pieces. Even six hundred years later, anyone walking into the mosque will readily agree that the sultan had every reason to be satisfied. The building is grand and imposing; the interior is rich in intricate detail, adorned with columns of porphyry and marble, with multicolored marble inlays, with gilt and painted carved wood and stone. It is balanced and appealing, but also has an air of loftiness and splendor that carries a clear message of the founder's regal power.

Barquq could hardly sit back and enjoy his architectural creation. His position on the sultan's throne, achieved after a long and often vicious struggle, was by no means secure. He belonged to the Circassian Mamluks, who were first brought in large numbers to Egypt by Sultan Qalawun to counterbalance the power of Kipchak Turk Mamluks. The Kipchak amirs were too busy fighting one another to prevent Barquq from seizing power, but once he was sultan, they grabbed the first opportunity to oust him. Four years after his *madrasa* was built, Barquq was deposed and exiled to Syria. He returned at the head of an army, but was defeated on the battlefield. Then, according to chroniclers, something quite extraordinary happened. In retreat, Barquq chanced upon the tent of the victors, the child sultan Haggi II and the caliph. (This was one of the rare instances when a puppet caliph residing in Cairo entered the historical stage.) Barquq managed to talk them into reinstating him as sultan, then stayed on the throne for nine more years, until he died of natural causes. What arguments did he use in that tent to convince his victorious enemies? Who among us wouldn't desire to have the power of speech capable of turning a kingdom's fortunes around?

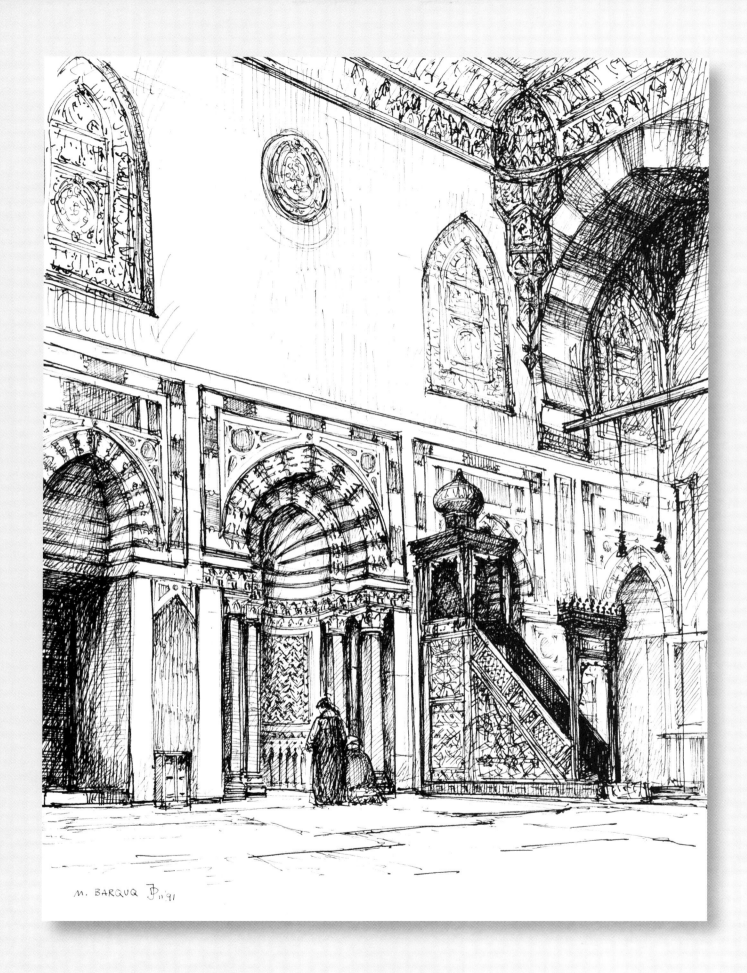

M. BARQUQ D.11.91

The Tomb
of
Yunus al-Dawadar

DATE: 1382
INDEX NO.: 139
LOCATION: E-4: *Bab al-Wazir Cemetery, close to the Citadel*

40

It is not unusual in medieval Cairo to find two different tombs built by the same person in different stages of life. An amir would order a domed mausoleum; later, when he became sultan, he would erect a bigger, more sumptuous one, better suited to the scale of the religious foundation he could then afford to endow. What is exceptional in the two mausoleums of Amir Yunus al-Dawadar is that they are completely different. The one in the Eastern Cemetery is a traditional early Mamluk dome built of brick. The other, next to the Citadel, is entirely in stone. It shows Persian influence, and is so elongated that it is almost tower-like. Indeed, many people mistake it for a minaret.

The career of Yunus, the secretary (*dawadar*) and confidant of Sultan Barquq, ended abruptly in 1389 when he was killed by marauding Bedouins on his way from Syria to Cairo. The level of personal security in the country torn by feuds and rivalries was no better than in medieval Europe.

Sultan Barquq, page 38

The tomb built earlier in the Eastern Cemetery was given to the father of Yunus' master, Barquq. When he became sultan, Barquq brought his family to Cairo. Much to the annoyance of the amirs, the monarch's father remained a hillbilly from the Caucasus in his manners, a tough and proud man unwilling to submit to court etiquette.

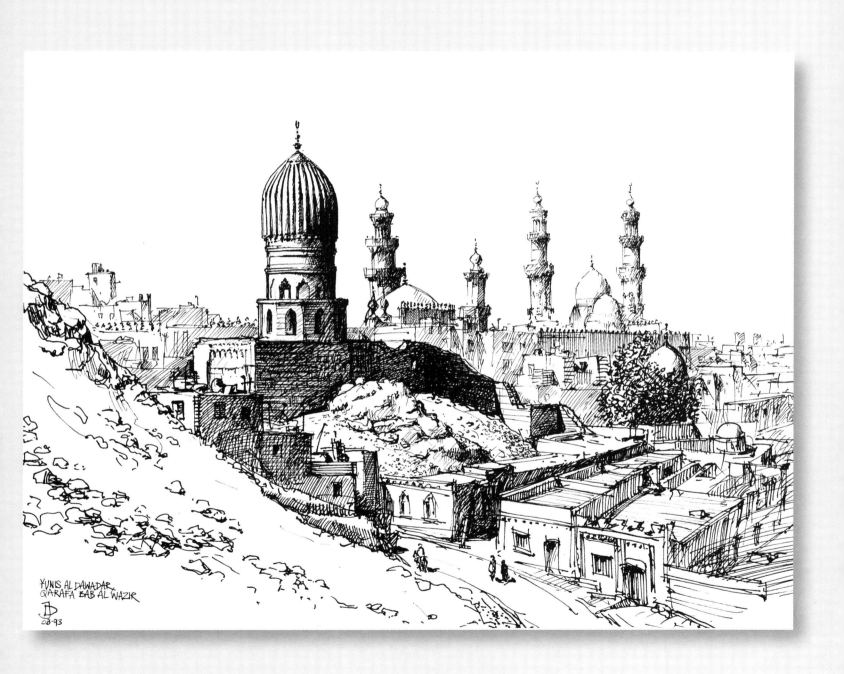

YUNIS AL DAWADAR,
QARAFA BAB AL WAZIR

DD
08·93

The Mosque
of
Sultan al-Mu'ayyad Shaykh

DATE: 1415–20
INDEX NO.: 190
LOCATION: D-3: *al-Mu'izz li-Din Allah Street, next to Bab Zuwayla*

Use of space in Islamic architecture: compare to the Madrasa of Sultan Qalawun, page 18, and the House of Gamal al-Din al-Dhahabi, page 90

The contrast between the peaceful, quiet greatness of the lofty arcades of the al-Mu'ayyad mosque and the noisy, crowded confusion of the commercial street outside is particularly striking. The mosque rises high and aloof over the street. Inside, the multitude of marble columns and graceful tall arches support, very high above, carved, painted, and gilded ceilings so intricate that they immediately bring to mind the flying carpet of the *Thousand and One Nights*. The decoration of the walls in multicolored marble and ceramic tiles, the inlaid doors, and colorful stained-glass windows are equally rich.

Light and shadows, changing with the seasons and with the time of day, interplay in ever-differing patterns within the mosque's spacious arcades, which defy the distinction between internal and external space. Paradoxically, this place of beauty and enchantment stands on the site of a prison where al-Mu'ayyad Shaykh was kept in his younger years, sentenced for excessive drinking. Languishing in a dungeon, he vowed to build a mosque if he was ever released, probably not expecting that changing fortunes would soon make him a sultan and provide him with the means to tear down the jail and replace it with one of Cairo's grandest buildings.

The contrast between the peaceful interior and the bustle outside is even stronger because of the trees growing in the enormous courtyard, as big as a sizeable city square. This is the only green area in the incredibly dense neighborhood. It is little wonder, then, that for many people the mosque is not only a place to pray, but also to rest or doze away. It also shelters dozens, perhaps hundreds, of cats, that graciously move about, following their own ways, seeking patches of sun in winter and shadows in summer, or dozing away too. The city is unimaginable without its plentiful cats, quite like the people of Cairo, endowed with cunning wit, indefatigable perseverance, and vain self-satisfaction.

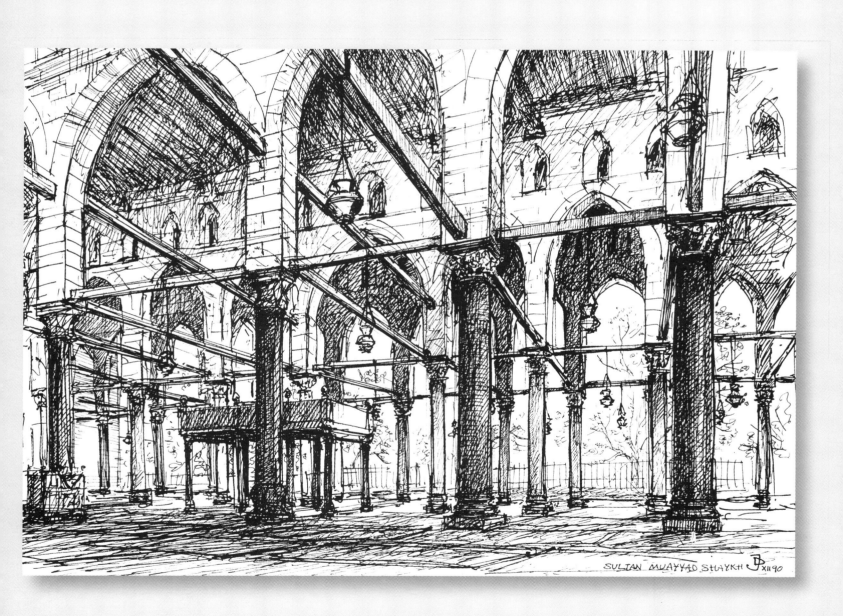

SULTAN MUAYYAD SHAYKH

The Madrasa and Tomb
of
Sultan Hasan

DATE: 1356–62
INDEX NO.: 133
LOCATION: D-4: *Muhammad 'Ali Square, below the Citadel*

Amir Shaykhu,
page 28

Salah al-Din Square is one of the few open spaces in Cairo, which is among the world's densest cities. This is the site of the Qaramaydan, the hippodrome where Mamluk cavalry perfected their renowned riding skills through playing polo. It extended into al-Rumayla, a parade ground. Today, it offers a grand view on the majestic complex of Sultan Hasan, one of the largest mosques in the world. Its massive stone walls, thirty-six meters high (the equivalent of twelve floors in a modern building), still give the impression of overpowering enormity. One can only imagine what a marvel they were for medieval travelers. The minaret soars to more than eighty meters, or two hundred and sixty feet.

When Hasan, son of the great sultan al-Nasir Muhammad, was chosen for the throne, he was twelve years old. The red-haired, freckled boy was a mere puppet for scheming dignitaries. Around the age of fifteen, he showed signs of independence, so he was deposed and sent to the harem. But he had a powerful protector in Amir Shaykhu, who reinstated Hasan as sultan. With Shaykhu running the affairs of the state, Hasan stayed on the throne. After his paladin was murdered, however, it did not take long before Hasan himself was assassinated, aged only twenty-six.

In 1347, the year of Hasan's first ascension, the sultan's court was certainly too busy with intrigues to notice that Genoese ships brought an unknown disease to Egyptian seaports. Soon, however, the plague could not be ignored, for it was the Black Death, which raged throughout the Middle East as well as Europe. Two years later a doctor in Muslim Andalusia wrote, "Never before has a catastrophe of such extent and duration occurred." In Cairo alone, 200,000 people perished within those two years, about two-fifths of the city's population. The death toll was high among the royal *mamluk*s, stationed within the confines of their barracks. Personal belongings of these elite troops of slave-soldiers reverted to their master when they died, suddenly swelling the sultan's coffers with gold. That unexpected wealth enabled young Hasan to embark on his construction project on an unprecedented scale.

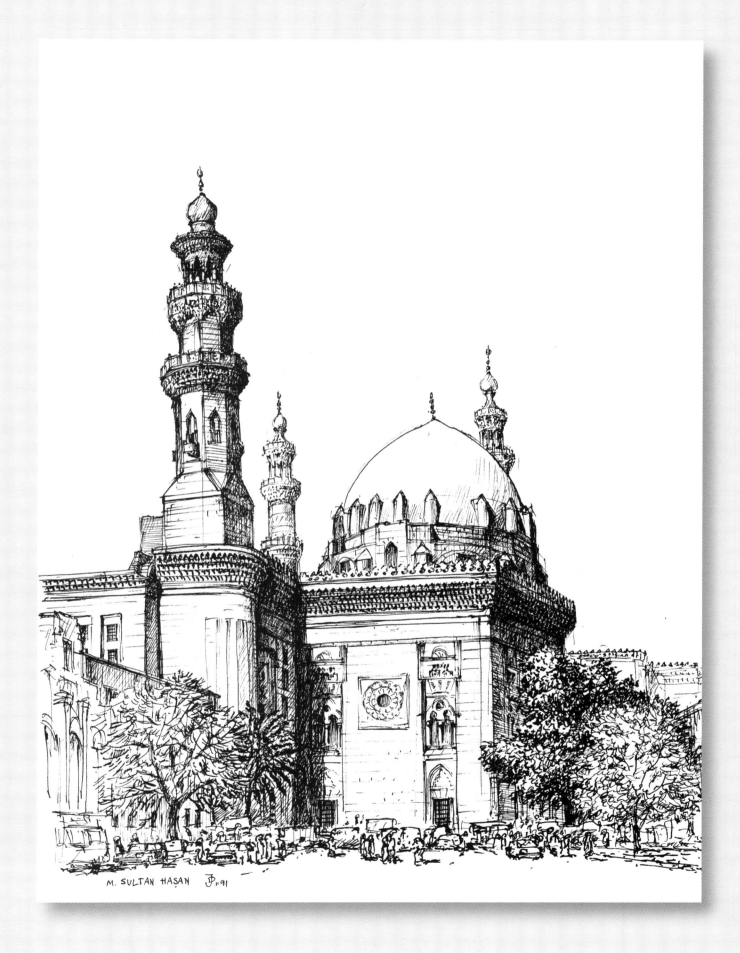

M. SULTAN HASAN JD 11.91

View *from* the Citadel

46

Sultan Hasan and his mosque, page 44

The Ottoman conquest: see the Mosque of Khayrbak, page 68

Few in the crowd of visitors who admire the magnificent sight of Cairo from the viewing terrace at the Citadel are aware that they are seeing the city from the same place the Mamluk sultans saw it. This is the location of the sultans' al-Ablaq Palace. Their view was different, though; most of the mosques at the foot of the Citadel are of a later date. Only the Mosque of Sultan Hasan, with its great domed tomb, has been there for more than six hundred years, its fate often linked with that of the Citadel. In turbulent Mamluk times, contenders to the throne would hoist catapults or cannons to the roof of the mosque and bombard the Citadel. The walls of the mosque are still scarred with returned fire. In 1517, the last Mamluk sultan, Tumanbay II, fled the Citadel and made his last stand in the mosque. More bombardment followed, and Turkish conqueror Selim the Grim had Tumanbay captured and hanged from Bab Zuwayla. Weakened by missiles, Sultan Hasan's dome fell in 1660, and was reconstructed eleven years later.

The modern Muhammad 'Ali Square between the mosque and the fortress was laid out in the late nineteenth century as a part of Khedive Isma'il's ambitious plan to turn Cairo into the Paris of the Orient. Before, the place had been the parade ground for Mamluk sultans' armies. The gate opening from the Citadel onto the square, with two crenellated round-fronted towers, is Bab al-'Azab (the Gate of Bachelors, after the name of an Ottoman infantry corps). In March 1811, some 470 Mamluk beys were heading home from a banquet at the Citadel, but they never made it through the gate. All but one were massacred at the order of their host, the cunning and cruel Muhammad 'Ali Pasha, from then on the sole, incontestable ruler of Egypt.

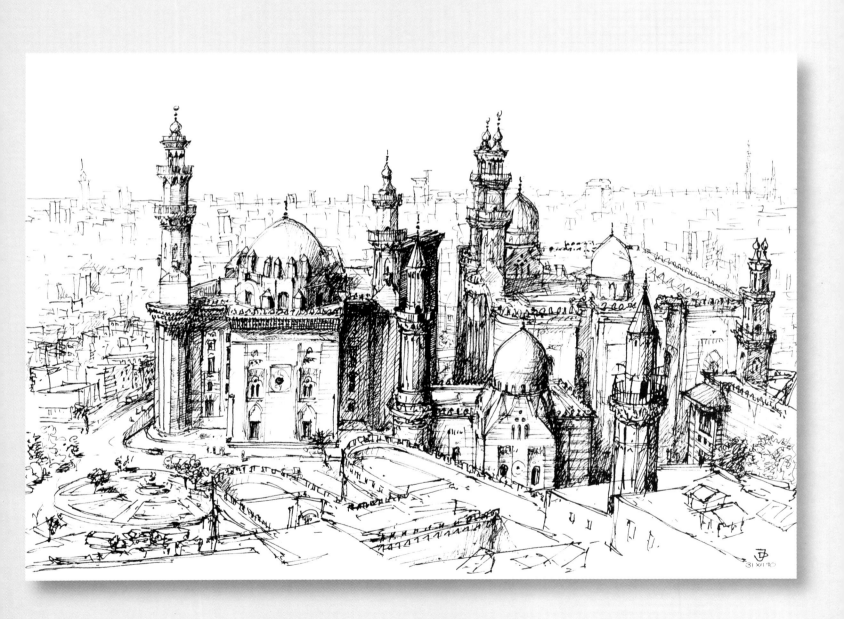

Mihrab in the Mosque
of
Sultan al-Ashraf Barsbay

DATE: 1432
INDEX NO.: 121
LOCATION: F-2: *Eastern Cemetery*

The Mosque of al-Nasir Muhammad, page 22

The massive walls of Cairo's mosques and houses were built of stone, but stone was also the material of the delicate patterns of the internal decoration. A recent study has identified as many as eighteen different kinds of decorative stone inside a single medieval prayer hall in Cairo. The polished, multicolored stone panels, the designs sometimes enhanced with glass paste or mother-of-pearl, were the glory of the interiors. Purple and black porphyry, green breccia, white, gray, red, or black marble were cut into pieces of various shapes to form wall panels, patterned floors, fountain basins. The craft was well rooted in Egypt: in the Greco-Roman period, the capital Alexandria was famous for its stone floor carpets, and marble tiles were exported from there to faraway destinations.

Most of the stone was recycled from earlier, ruined buildings. This was always the case in Egypt. Even in ancient temples, such as Luxor or Karnak, stone blocks were routinely reused and recarved, often many times. It is not uncommon in Cairo to see stones from pharaonic buildings: not long ago an Egyptologist was teaching his students to read hieroglyphs by taking them to the reused blocks in the northern walls of al-Qahira. Most of the columns in the mosques of the city have been taken from ancient temples, palaces, or churches. Because decorated stone was so highly valued, many architectural details were brought to Cairo as spoils of war from Crusader states. An especially noticeable example is an entire marble portal now in the mosque of al-Nasir Muhammad. In the end, many mosques, houses, and palaces in Cairo met the same fate: they were stripped of their precious marble decorations, carried away to adorn buildings in Istanbul, or simply stolen. But enough stonework remains to be admired, such as in the mosque of Sultan al-Ashraf Barsbay, a man known for his integrity and the conqueror of Cyprus. The *mihrab* (the niche marking the direction of Mecca), beautifully wrought in polished stone, is the focus of the interior in his mosque in the Eastern Cemetery. In front of it, the cenotaph of the pious sultan is placed as if to symbolize perpetual prayer.

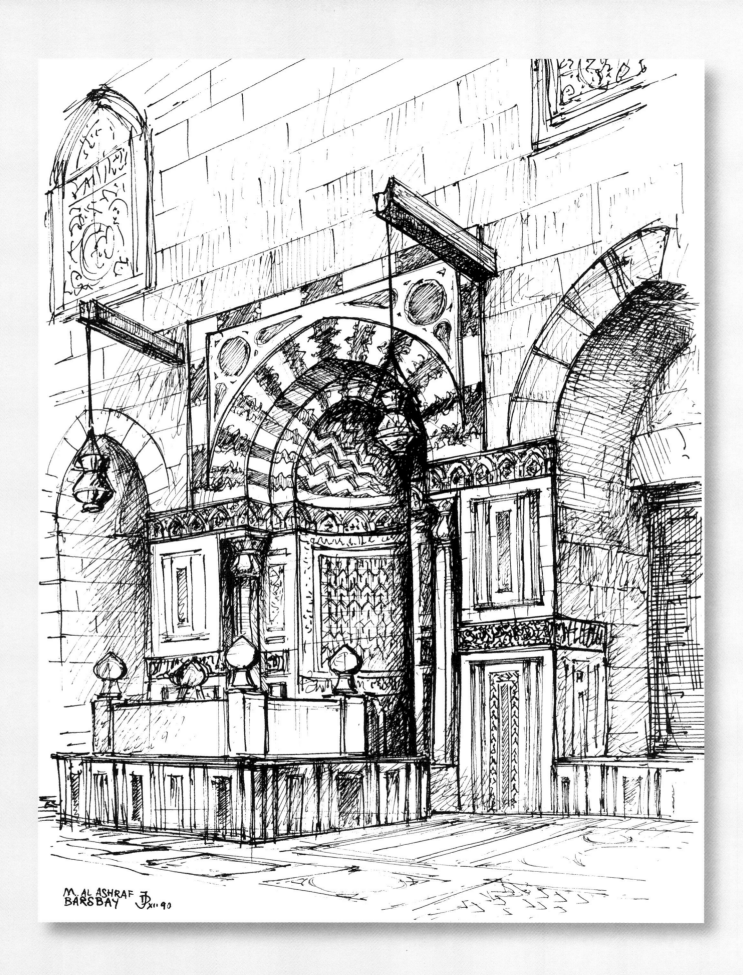

M. AL ASHRAF
BARSBAY JD XII 90

The Mosque
of
Amir Altinbugha al-Maridani

DATE: 1339–40
INDEX NO.: 120
LOCATION: D-3: *al-Darb al-Ahmar Street*

*The Mosque
of Sultan Hasan,
page 44*

On January 12, 1839, David Roberts sat sketching in the courtyard of the Mosque of Sultan Hasan. The drawing was rendered into a lithograph in the monumental series illustrating his travels in the Middle East. The mosque has changed little since then, but one of the two ablution fountains has vanished from the courtyard. It did not perish, though: the domed structure shown on Robert's lithograph can be immediately recognized as the one now standing in the Mosque of Altinbugha al-Maridani. The transfer of the charming canopied fountain was but one of numerous restorations by the Comité de Conservation des Monuments de l'Art Arabe, an organization active between 1882 and 1954. Hardly a historic building in Cairo does not bear the stamp of the Comité's work. Many of today's conservators would not approve their bold interventions. Sometimes their work is seen as an attempt to impose foreign Orientalist ideas on the living city. Whatever critics may say, the fact remains: the Comité saved the monuments of Cairo. Without their work, the buildings we now admire would have been lost forever, like so many other houses, mosques, and minarets that have vanished without a trace.

In the Mosque of al-Maridani, the Comité's interventions were quite comprehensive, but faithful to the original. Their restoration preserved the magnificent wooden screen separating the courtyard from the sanctuary and the exquisite marble lining of the walls, as well as the minaret, the first one of the type that was to become a hallmark of Cairo's skyline.

*Sultan al-Nasir
Muhammad: see the
Khanqah of Sultan
Baybars II, page 24*

*Sultan Kujuk:
see page 72*

Amir Altinbugha al-Maridani's career started with good prospects when he married a daughter of the powerful Sultan al-Nasir Muhammad. The sultan's chief architect was assigned to oversee the work on the mosque. When his protector al-Nasir died and a turbulent period of struggle for power ensued, al-Maridani was arrested and imprisoned. His fortunes quickly changed, for he was soon freed by Qawsun, the powerful protector of the child sultan Kujuk, and appointed the governor of Aleppo. His new paladin soon perished too. Al-Maridani never returned to Cairo to take part in the continuing fight for power. He was not yet twenty-five years old when he died in Syria.

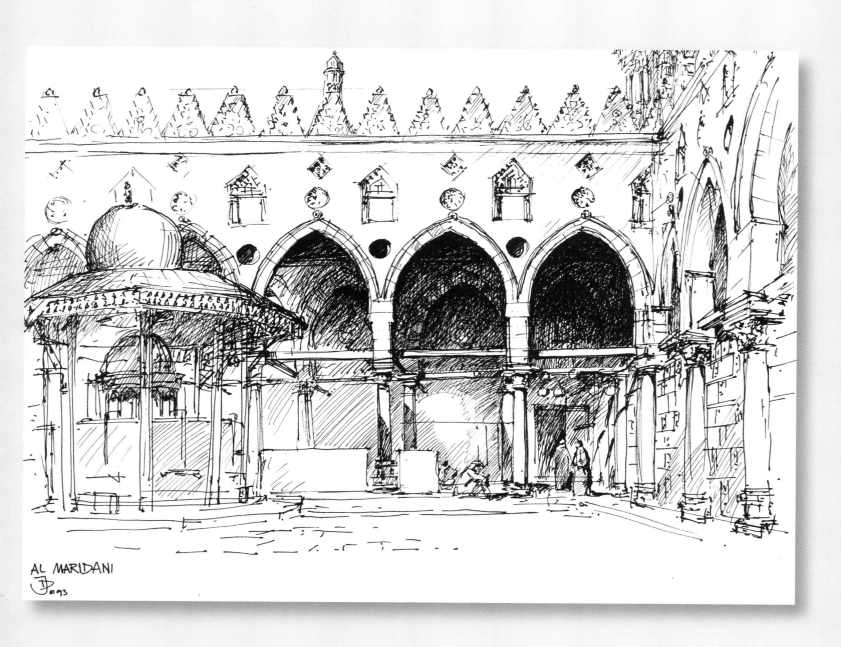

AL MARIDANI

The Mosque
of
Qagmas al-Ishaqi (Abu Hurayba)

DATE: 1480–81
INDEX NO.: 114
LOCATION: D-3: *al-Darb al-Ahmar Street*

Al-Darb al-Ahmar,
page 36

52

mir Qagmas al-Ishaqi, the founder of the mosque in al-Darb al-Ahmar, held high offices in the service of Sultan Qaytbay, one of the few Mamluk rulers who died peacefully after a long reign. The sultan stayed in power for twenty-eight years, and passed away quietly at the age of eighty-six. His kingdom, however, was far from peaceful. The warring Mamluk factions rioted, the plague raged in the country, and an economic downfall took its toll on the oppressed population. The sultan himself was as rapacious, tyrannical, and extortionate as any other Mamluk ruler.

Nonetheless, Qaytbay was a great patron of arts. Under his rule the stone architecture of Cairo reached unprecedented refinement. This was the classical period that has defined the city's image. Slender minarets crowned with gracious pavilions and bulbous tops, the balanced harmony of the rich façades, stone domes carved in intricate patterns—Qaytbay's Cairo has provided generations of visitors with the archetypal vision of the Islamic Orient. Scores of buildings founded by the sultan have survived in Cairo and in provincial cities. His leading amirs followed his example and founded ornate structures in the same style.

One of the amirs was Qagmas, a pious and respected man whose career was crowned with the post of the viceroy of Syria. He added a domed tomb to the mosque he founded in Cairo, but he died in Damascus and was buried there. A local shaykh, Abu Hurayba, was interred under the dome in the mid-nineteenth century, and in the neighborhood the mosque is known by his name.

The mosque is classic in its elegant architectural style, but also in another important feature of Qaytbay's period architecture: that it never loses its human scale. It is grand, but not overwhelming; ornate, but neither pompous nor extravagant. It is also inseparable from the fabric of its neighborhood, with the row of shops in the ground floor, with subsidiary rooms still used for a variety of activities, with the building's arrangement conforming to the bend of the street.

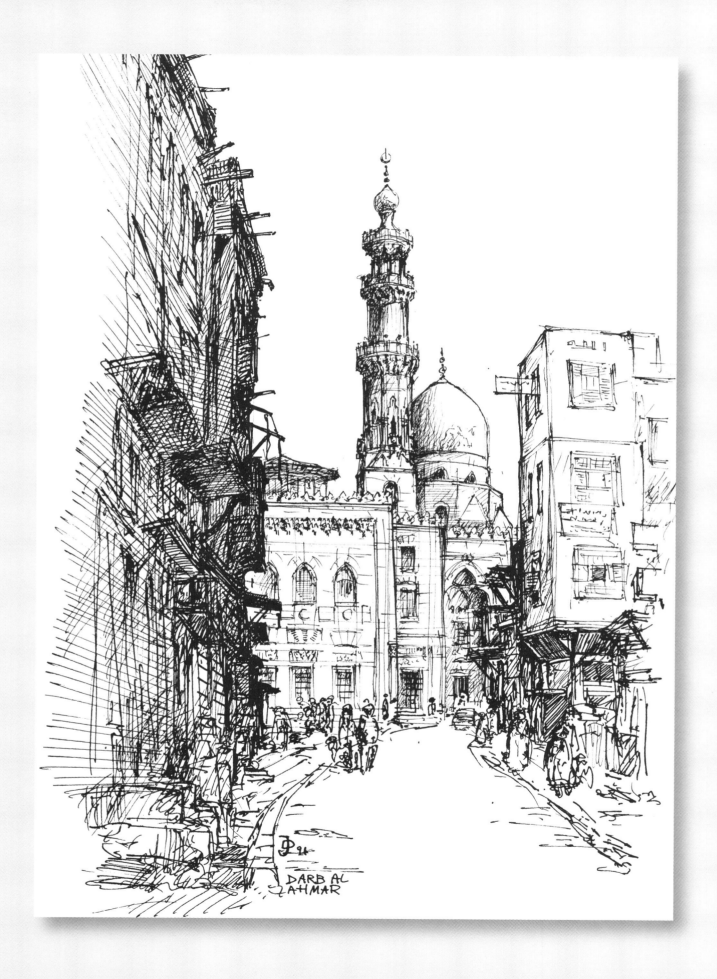

DARB AL
AHMAR

The Mosque
of
Qagmas al-Ishaqi (Abu Hurayba) — Interior

DATE: 1480–81
INDEX NO.: 114
LOCATION: D-3: *al-Darb al-Ahmar Street*

*Qagmas al-Ishaqi
and his mosque,
page 52*

Most of the master builders and craftsmen who created the architectural wonders of historic Cairo remain anonymous. Just as in medieval Europe, we usually know much more about the people in power who ordered the construction than about the real creators of the buildings. Of the latter, we sometimes catch momentary glimpses: an isolated biographical fact, an anecdote, a name. In the mosque of Qagmas, the decorator Abd al-Qadir left his signature carved in marble in beautiful calligraphic script. This inlaid signature is a part of the marble lining the walls, with inlays forming a delicate lace of floral motifs, geometric patterns, and decorative lettering. It is certain then that the marble was Abd al-Qadir's work, but was he the author of the carved decoration on the external and internal stone façades? Of the exquisite woodwork? Of the intricate stained-glass window panels, which add to the magical quality of the interior with shifting beams of colorful light? It is hard to say, because the word 'decorator,' which he used to describe his trade, is rather ambiguous. One would also like to learn whether he was the architect who masterfully designed the unusual and ingenious layout of the building, but we will probably never know.

The work ordered by Amir Qagmas represents late Mamluk art at its best. Even the relatively small size of the building is typical of the period. All components are present, complete, and executed with the utmost mastery. The proportions of the *madrasa* are grand, but not overwhelming. The small central courtyard has been covered with an elaborate wooden roof pierced with large windows, adding to the aura of coziness. The decoration is profuse, sophisticated, and rich, but always in harmony with architectural divisions. Yet there is a quality to the interior that cannot be described in architectural terms: the phantasmagoric play of sun rays coming like colored stage lights through the stained-glass windows.

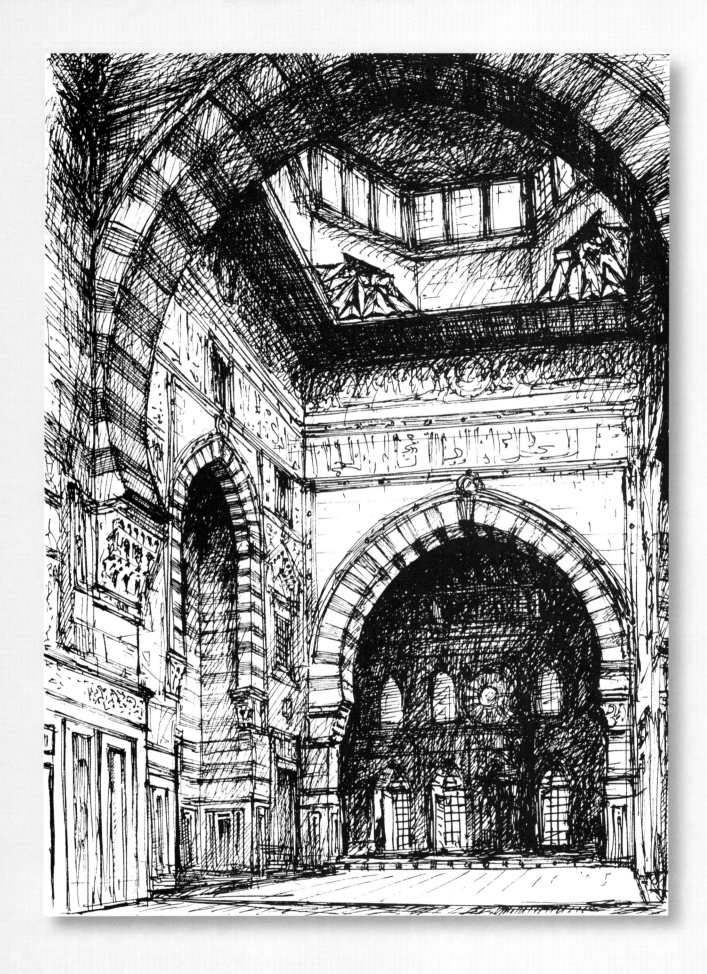

Abu Hurayba Street
by
the Mosque of Qagmas al-Ishaqi

DATE: 1480–81 (MOSQUE)
INDEX NO.: 114 (MOSQUE)
LOCATION: D-3: *al-Darb al-Ahmar*

The Mosque of Qagmas al-Ishaqi: Interior, page 54

Al-Darb al-Ahmar, page 36

Cairo in Mamluk times was a dense, crowded city. Land in prime locations was precious, so the architects working for Mamluk patrons had to conform their designs to small, irregular lots in the closely built-up city. In doing so, they exercised remarkable ingenuity. In religious buildings, where the prayer hall had to be oriented toward Mecca, the task was particularly hard. Often, behind formally arranged façades are equally formal interiors, but of a different alignment, achieved by such devices as walls of varying thickness and obliquely cut windows.

The architect of the mosque of Qagmas al-Ishaqi had scant space to fit in all the required components of a religious and funerary complex. Moreover, the lot at his disposal was bisected by a street, so accordingly, the building was divided. The principal part, with the mosque–*madrasa* and the founder's tomb, proudly stands on the main thoroughfare, al-Darb al-Ahmar Street. Subsidiary structures, including the ablution area, face the side lane and are connected directly to the mosque—the main floor of which is raised above a row of shops—by a covered bridge over the street. The mosque still serves the neighborhood, so people going to prayer cross the bridge every day. The shops underneath the mosque are also continuously in use. The neighborhood is a hive of activity, a place where an unprepared visitor from the West can experience a mild case of culture shock (only to learn very soon that this is in fact a very friendly environment).

The mosque will probably continue to be a place of prayer regardless of what happens to the community, but how much longer will it survive as a part of the city's living tissue? How long will people work and trade in the vaults designed for that purpose in the Middle Ages, before some official decides from behind his desk that ordinary people and neighborhood workshops are an offense to the national heritage? That the only sights acceptable on historic sites are padlocks on empty buildings facing bulldozed lots, or kitschy fake pharaonic souvenirs sold to tourists from plywood stalls?

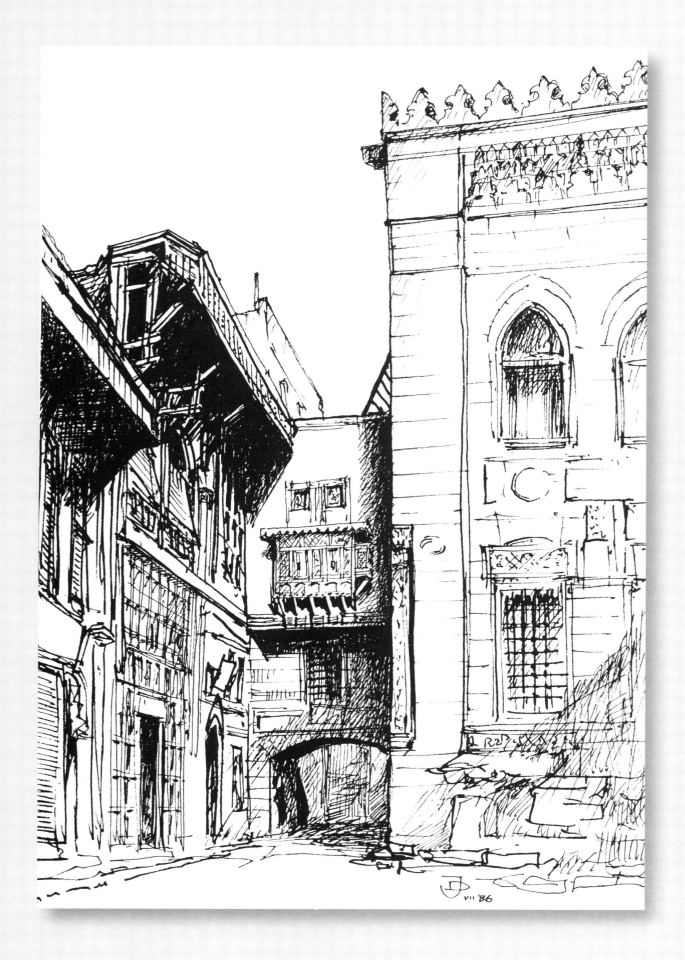

The Madrasa
of
Inal al-Yusufi

DATE: 1392–93
INDEX NO.: 118
LOCATION: D-3: *al-Khiyamiya (the Tentmakers') Street*

Inal, known as al-Yusufi or al-Atabki, was one of the amirs involved in the struggle for power after the death of Sultan al-Nasir Muhammad. Al-Nasir himself was deposed twice in his early years, but finally managed to bring some stability to the country during his long third reign. As soon as he died in 1340, however, fighting over succession drove Egypt into turmoil again. In 1357, Sultan Hasan, one of al-Nasir Muhammad's sons and the builder of a magnificent *madrasa* below the Citadel, lost his powerful protector, Amir Shaykhu, who was murdered by the royal *mamluk*s. Inal sided with the rebellious amirs, who soon deposed and assassinated the vulnerable young ruler. Although this faction did not hold on to power for long, Inal was made the viceroy of Syria and survived the calamitous times. When Sultan Barquq sat firmly on the throne, he rewarded Inal with the title of *atabak*, commander of the army. In this capacity, he built the *madrasa* on Cairo's main thoroughfare.

By this time, the city had become quite dense. The leading architectural theme was no longer a giant courtyard mosque (although some were still to be built), but a more compact *madrasa*, a teaching institution, serving also as a place of prayer. A public fountain and elementary school (*sabil–kuttab*) were always attached, and often other charities as well. All this commemorated the founder, whose domed tomb was a part of the complex. Invariably, a minaret was also erected. The Mamluk minarets were surmounted by bulbous domes on slender marble columns, but these graceful structures were too delicate to last. By the late nineteenth century, all had either collapsed, been walled up, or replaced by simple Ottoman structures with pencil-like conical roofs. The captivating skyline of today's historic Cairo is made up of reconstructions. But the minaret of Amir Inal's *madrasa*, while unimposing, is authentic: it is what has really come down to us from the past.

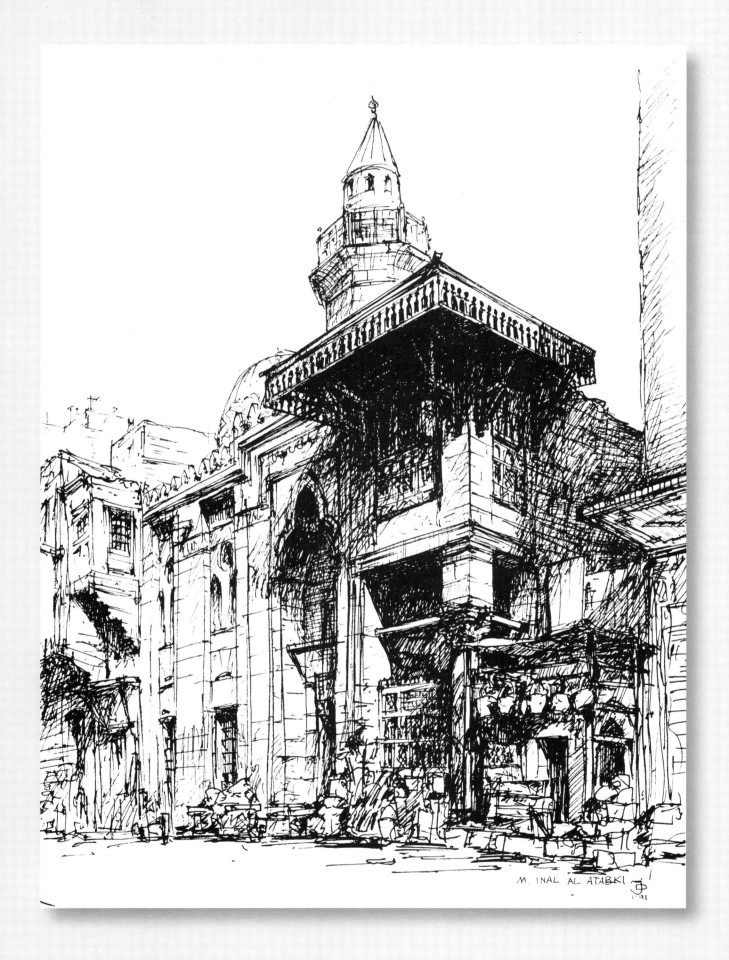

M. INAL AL ATABKI
1991

Mausoleum
of
Sultan Qansuh Abu Sa'id

DATE: 1499
INDEX No.: 164
LOCATION: F-1: *Eastern Cemetery*

*Sultan Qaytbay: see
the Mosque of
Qagmas al-Ishaqi,
page 52*

The domed tomb built for Sultan Qansuh Abu Sa'id stands alone in the median of a throughway bisecting the Eastern Cemetery, an island in the stream of traffic. In photographs from the early twentieth century, the cemetery—now completely built up with new tombs and houses—was nothing but an empty stretch of the desert, scattered with isolated domed mausoleums. But that picture is misleading. When they were erected in the Middle Ages, the tombs were not meant to stand alone in the desert; they were parts of large religious complexes endowed as charities in their founders' memory.

The fine tomb of Qansuh is known as the Dome of the Watchman, probably because it stood at the northern limit of the burial ground. It used to mark the border between the deadly emptiness of the desert and the cemetery, an area designated for the dead, but alive with Sufi convents, charitable institutions, prayers constantly said over the tombs, and visiting parties at their ancestors' graves. Today, Qansuh's dome marks the border between the cemetery—a dusty, quiet expanse belonging to the dead—and the noise, commotion, and heavy traffic of the modern city.

Qansuh Abu Sa'id was originally a *mamluk* of the great builder Sultan Qaytbay. Qansuh's tomb displays architectural refinement similar to his master's creations. Interestingly, the lively floral patterns found on Qaytbay's buildings were replaced here with equally exquisite but purely geometrical ornaments.

Qansuh's career received a boost when it turned out that he was a brother of Sultan Qaytbay's favorite consort. After Qaytbay's death, Qansuh was a protector of the sultan's son and successor, who reigned for only two years before discontented Mamluks assassinated him. Qansuh himself was then elected sultan, but within a year the Mamluks revolted again, led by Amir Tumanbay. Qansuh tried to flee disguised as a woman, but was caught and exiled to Alexandria by the next sultan, Janbalat. Tumanbay kept scheming; he soon deposed Janbalat and had him and Qansuh strangled. But Tumanbay only survived on the throne for a year before he too was executed.

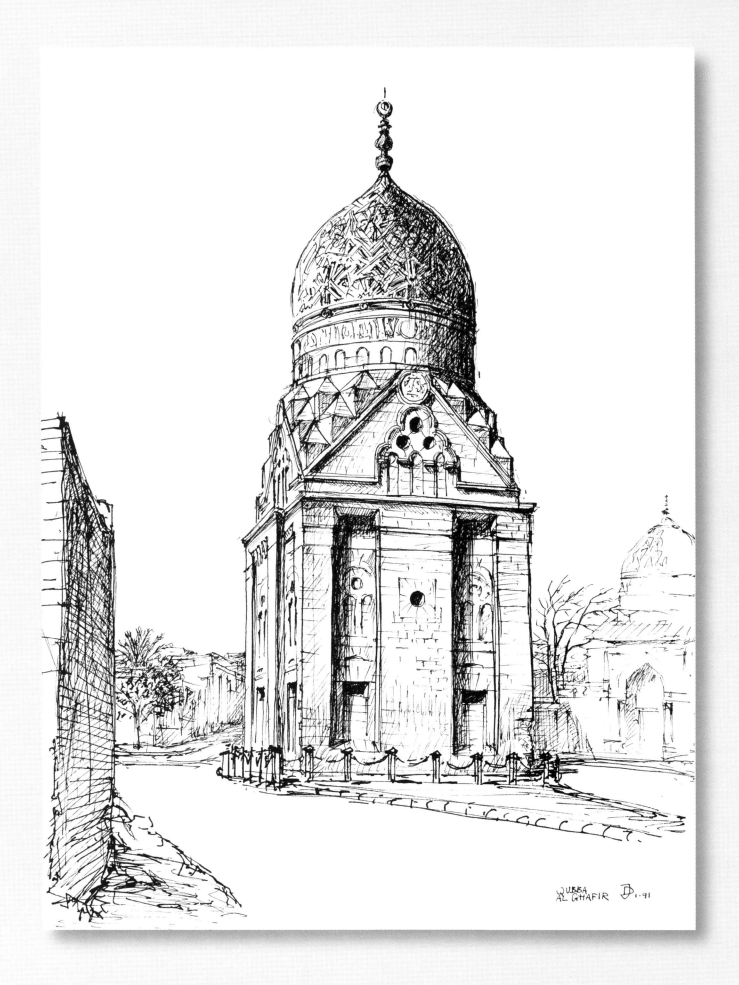

QUBBA
AL GHAFIR D 1·91

Al-Fidawiya Dome

DATE: 1479–81
INDEX NO.: 5
LOCATION: *al-ʿAbbasiya Street, between Midan al-Gaysh and Midan ʿAbbasiya (off the map)*

The Madrasa of Sultan Hasan, page 44

Bab Zuwayla, pages 8, 10

By the fifteenth century, the profile of the Mamluk dome had been refined to perfection. The floral and geometric decoration carved on the stone surfaces was lavish and ingenious, but the elegant silhouettes were so standardized that it takes a second look at the al-Fidawiya dome to realize how unique it is among its contemporaries. It is built of bricks, not stone, and covered with plain plaster. The dome rests directly on the perfect cube of the mausoleum, while in other contemporary buildings there was an intervening zone developed into elaborate designs. On the façades, nothing detracts from the simple tripartite divisions. Perhaps the noble austerity of the building was a reflection of the renowned integrity of its founder, Yashbak min Mahdi, the *wazir* of Sultan Qaytbay. The gigantic ruins of his palace, with its empty circular windows gaping in walls of enormous stone blocks, still loom hauntingly over the district of Hilmiya, next to the *madrasa* of Sultan Hasan.

In the al-Fidawiya dome, the refined restraint of the exterior only enhances the perfection of stonemasonry and the richness of the internal decoration in multicolored marble and painted stucco. The interior is not accessible nowadays, though, and the building, which was once just one part of a large palatial complex, now stands alone within its little garden, the only green space in a neighborhood crowded with nondescript houses, brimming with cars, and busy with every possible kind of trade.

Yashbak's moment of glory was the day in 1472 when he brought in chains to Cairo the defeated ruler of the White Sheep Turkomans. On that day, one could easily believe that the formidable Mamluk cavalry would deal with the advancing Turks just as it had done when Baybars al-Bunduqdari checked the invasion of the frightful Mongols 213 years before. But the Mamluk state was already in decline, and in 1517 the body of the last sovereign sultan, hanged by the Turkish conqueror, swung from the gate of Bab Zuwayla.

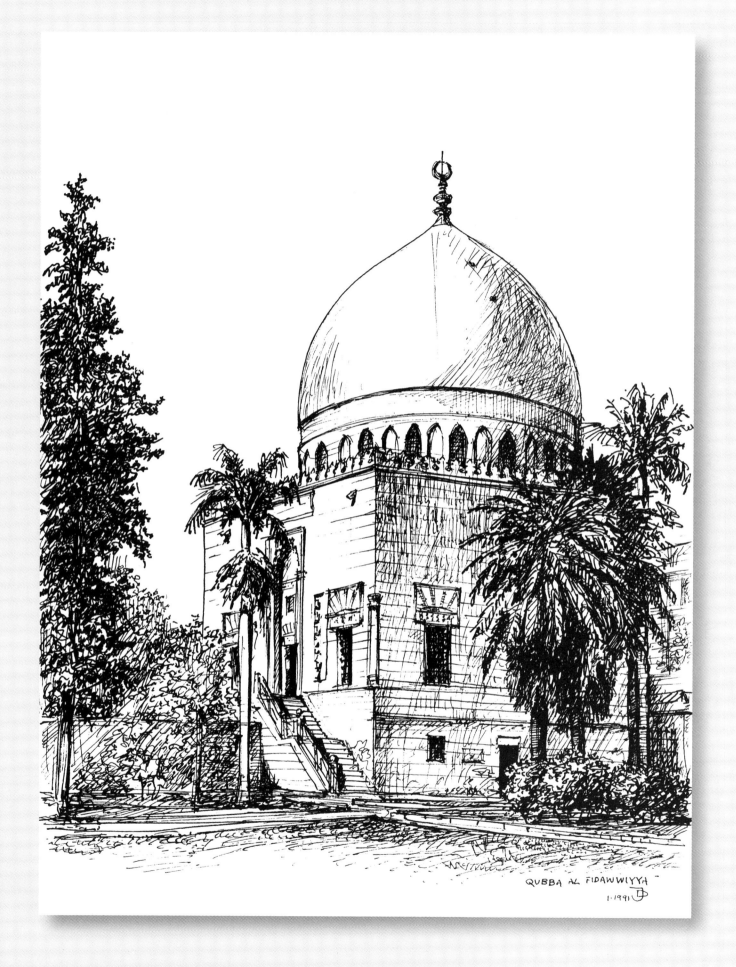

QUBBA AL FIDAWWIYYA

1·1991

Tomb
of
'Ali Nagm

DATE: C. 17TH CENTURY

INDEX NO.: 359

LOCATION: D-3: *al-Darb al-Ahmar (al-Quraybiya Street), close to Bab Zuwayla*

*E*ven today, now that Cairo has grown into a mammoth modern metropolis, the elegant silhouettes of stone domes, along with hundreds of minarets, still define the skyline of the city. Domed mausoleums were built in Cairo for centuries, but it was in late Mamluk times, from the fourteenth century on, that the domes assumed their perfectly refined form. The shape and structure was quite uniform, although the geometric and floral patterns carved on the stone shells were incredibly diverse. A dome would typically cover a mausoleum, and the tomb would be attached to a larger religious complex, endowed as a charity. The complex would contain a mosque, schools, a public fountain and drinking trough, accommodations for Sufis, and sometimes even a hospital—all as testament to the charity and piety of the founder, over whose tomb, sheltered under the dome, prayers would be continuously said. Whoever was in power at the Citadel was always busy constructing a dome for his own interment, probably knowing that he had only a slim chance of holding power for long. If they could afford it, those not in the ruling elite built mausoleums less sumptuous, but composed of the same architectural elements.

The tomb bearing the name of the seventeenth-century shaykh 'Ali Nagm displays in a quite charming way all the features present in the grand domes of the Mamluk sultans, only in a miniature scale. The tomb, built before Shaykh 'Ali's time, together with a half-ruined building containing a small prayer hall, are hidden in a small alley branching off the covered streets of the Tentmakers' Bazaar. This is one of the places in Cairo that seem remarkably lost in time. Though small Suzuki trucks have replaced donkeys and camels, the trucks are treated much the same way that the beasts of burden would be (they are even locally called 'water buffaloes'), so the change does not seem so substantial after all.

Al-Khiyamiya Street: the Tentmakers' Bazaar, page 94

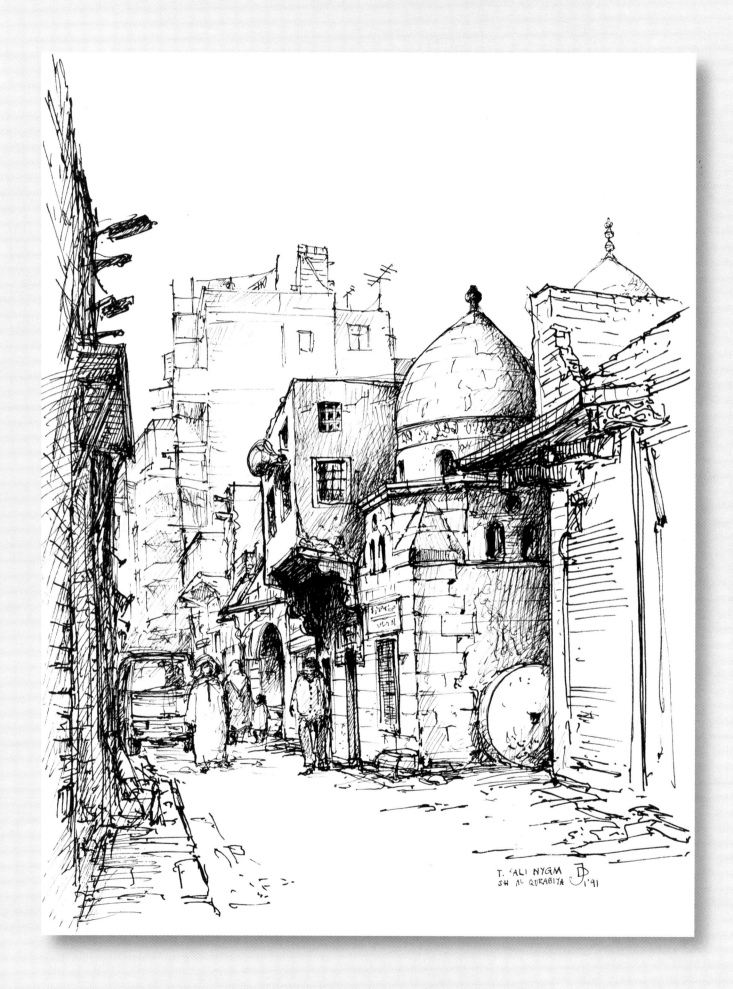

T. 'ALI NYGM
SH AL QURABIYA '91

The Madrasa
of
Baybars al-Khayyat

DATE: 1515
INDEX NO.: 191
LOCATION: D-3: *al-Ghuriya, between al-Muʿizz li-Din Allah and Bur Saʿid Streets*

See al-Sulaymaniya Mosque, page 70

Khanqah of Sultan Baybars II al-Gashankir, page 24

The Mosque of Amir Khayrbak, page 68

The skyline of medieval Cairo in the late Middle Ages was a silhouette of hundreds of minarets and countless domes. The majority of the domes covered tomb chambers attached to larger religious complexes; only in Ottoman times, from the sixteenth century on, does one find whole mosques covered with huge domes. Some domes were built of brick, or even wood (such as the famous one over the tomb of Imam al-Shafiʿi), but the hallmark of Cairo was the carved stone dome. The art was mastered in late Mamluk times, from the fourteenth century on, and the builders brought the boldly carved floral and geometric patterns to a level of unmatched refinement. Some medieval domes still figure prominently in the city's skyline, while others are lost in the maze of later buildings. One such monument, now hidden within a residential area, is the tomb of Baybars al-Khayyat. It is the only surviving original part in the religious complex that was largely reconstructed in the nineteenth century.

The tomb was built in 1515. Its founder, Amir Baybars al-Khayyat, should not be confused with the two sultans named Baybars who ruled Egypt in the thirteenth and early fourteenth centuries.

This amir served Sultan Qansuh al-Ghuri, the unlucky aesthete and art lover who wept when he had to abandon poetry for politics after he was elected to the sultanate. Two years after the construction of his *madrasa* and tomb, Baybars commanded a section of his master's army in the battle with the invading Ottomans at Marj Dabiq in Syria. A fellow commanding amir, Khayrbak, treacherously defected to the Ottomans, and the outcome was disastrous for the Egyptian army. The sultan died; Baybars al-Khayyat was taken prisoner. The lost battle sealed the fate of the sovereign Mamluk sultanate in Egypt.

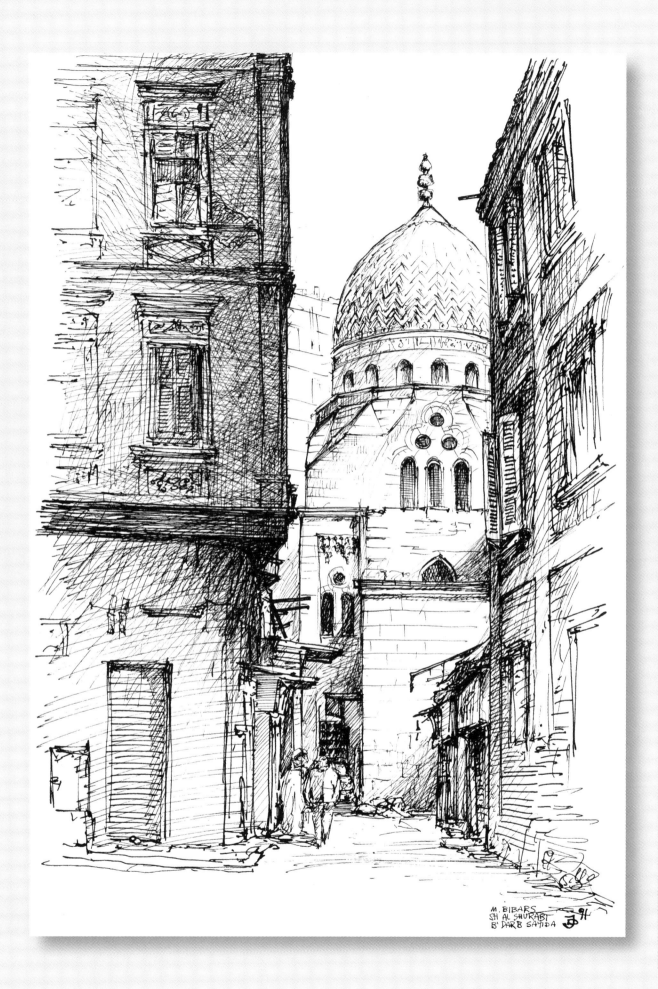

M. BIBARS
SH. AL SHURABI
B' DARB SA'IDA

The Mosque
of
Khayrbak

DATE: 1502 AND AFTER 1517
INDEX NO.: 248
LOCATION: E-4: *Bab al-Wazir Street*

The man who is buried under the exquisitely carved stone dome on Bab al-Wazir Street was the effective ruler of Egypt for more than four years, long enough for the suffering population to rejoice when death terminated his ruthless rule. His predecessors reigned from the Citadel as the suzerains of an empire comprising Egypt, Syria, and Nubia. He was a governor serving a foreign overlord, the Ottoman sultan from Istanbul. That sultan, the rapacious conqueror Selim the Grim, rewarded Khayrbak's services with the viceregal position in Egypt, but thereafter mockingly called him Khaynbak, playing on the word for 'traitor.' The reason for the disrespect was the treacherous way in which the amir defected from his former lord and benefactor, the Mamluk sultan Qansuh al-Ghuri. In the decisive battle of Marj Dabiq in 1517, Khayrbak, then the governor of Aleppo, went over with his troops to Selim's camp.

He had his domed mausoleum built in Cairo twelve years before the Turkish conquest. The carving of the floral patterns on the dome is among the most beautiful in the city. The tomb stands amid a cluster of earlier monumental buildings on the street that ran from the seat of power at the Citadel to the gate of Bab Zuwayla, and on to the commercial center of the capital. Throughout the centuries, numerous rulers and powerful Mamluks embellished the prestigious street with glorious mosques, public fountains, and palaces. Later, after Khayrbak was made the governor of Egypt, he added his mosque and the minaret. He adopted Turkish language, dress, and manners, but the building he founded is purely Mamluk in style. The local architectural traditions prevailed over political servility. The minaret does not differ from those built for earlier Mamluk patrons.

The Bab al-Wazir Cemetery, see page 72

Other important buildings along the street, see pages 36, 52, 86

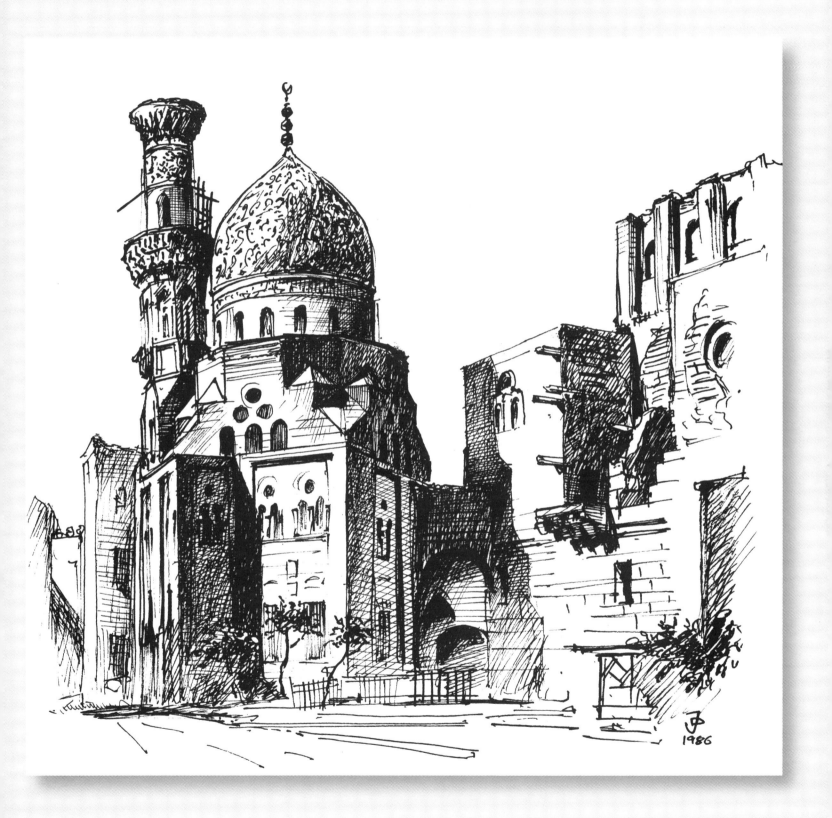

The Sulaymaniya Mosque
at
the Citadel

DATE: 1528
INDEX NO.: 142
LOCATION: E-4: *the Citadel, Northern Enclosure*

The typical mosque in medieval Cairo was built around an open courtyard. This followed a centuries-old tradition of architecture suited to the climate in the lands that constituted most of the Islamic world, including Egypt. The courtyard was the heart of every merchant's house, just as it was the design principle of every *madrasa*. Even large mosques consisted of rows of open arcades surrounding a central courtyard.

In the mosque of Sulayman Pasha at the Citadel, built shortly after the Ottoman conquest, this principle was completely turned around, or rather, inside out. Here, a forecourt with an entrance arcade is placed outside, while the prayer hall is a fully enclosed interior space covered with a huge dome. The external silhouette of the mosque, ascending toward the central dome, is reminiscent of Byzantine churches. This is not surprising, for Constantinople fell to the Ottomans sixty-four years before Cairo. The Turkish conquerors were familiar with the Eastern Orthodox churches and styled their architecture largely after these structures, which were much better suited to the harsher climate of Turkey than an open courtyard was.

Today, the mosque, tucked away in the Northern Enclosure, usually escapes the attention of the crowds visiting the Citadel. Its rather austere exterior does not betray the jewel-like splendor inside. The refined internal decoration is in a purely local, Mamluk style. The Cairene craftsmen who executed the exquisite marble inlays, stone carving, and calligraphic ornaments on the dome could just as well have worked for a Mamluk amir as for the Turkish pasha. This was perhaps emblematic of Egypt's fate. The Ottomans remained the overlords, but the local beys continued to be the real masters of the country.

Transition from Mamluk to Ottoman rule: see pages 66, 68

By the time the mosque was built, though, its founder, the Ottoman governor Sulayman Pasha, was firmly in control. Erecting a mosque in such a distinctly Turkish style on the Citadel hill—which had been the seat of Egyptian suzerains for more than three hundred years—carried a clear political message.

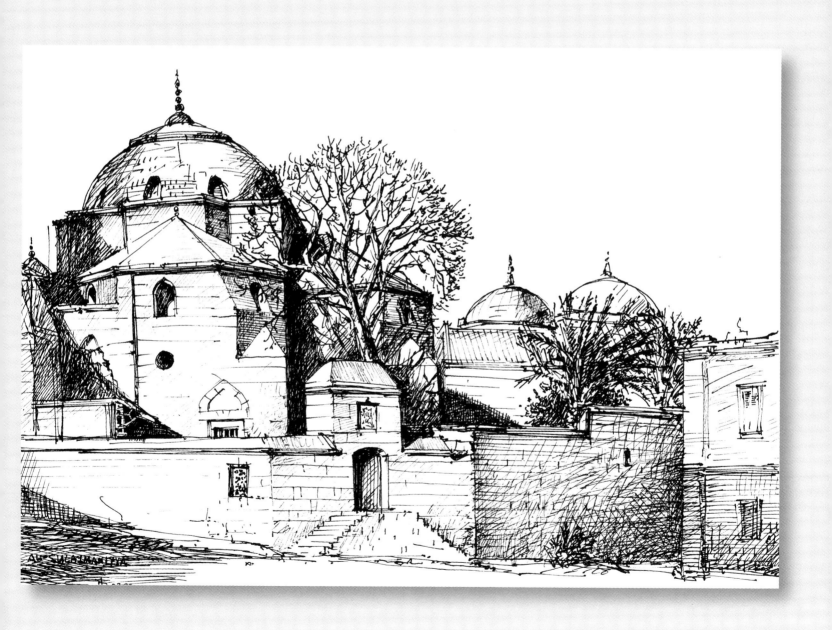

The Tomb of Tarabay al-Sharifi and Bab al-Wazir Cemetery

DATE: 1503
INDEX NO.: 255
LOCATION: E-4: *Bab al-Wazir Cemetery, off al-Darb al-Ahmar (al-Tabbana) Street*

The top of an arched gateway sticks out of the ground next to Bab al-Wazir Street where it descends from the Citadel hill toward the cemeteries. The ground level has risen over the centuries, so that what used to be a monumental portal is now half buried, serving as an unimposing passage into a neglected lot at the edge of the graveyard. This is the setting of the mosque of Mangak al-Yusufi, rebuilt many times since its construction in 1349. A climb up the dusty staircase of its minaret is rewarded with a magnificent view over the city: a remarkable surprise, considering that the minaret is not a well-exposed landmark.

A beautifully proportioned and exquisitely decorated mausoleum with a zigzag pattern carved on its stone dome dominates the view across Bab al-Wazir Cemetery. This is the tomb built in 1505 for Tarabay al-Sharifi, the commander of the Mamluks under Sultan Qansuh al-Ghuri.

In front of it is a smaller, simpler mausoleum from the late fourteenth century, the tomb of Sandal al-Mangaki, who was a eunuch of Greek origin, treasurer of Sultan Barquq, and renowned for his piety. Although more than two hundred years passed between the construction of the two domes, their form is essentially the same; only the decoration developed.

The stretch of empty land behind marks the location of Saladin's walls, built to join the Citadel with the walls of al-Qahira. Farther away, the multitude of minarets and domes testifies to centuries of history, but also to passions, intrigues, and changing fortunes of the people who wanted these stones to immortalize their names. There is the dome and the minaret of Amir Khayrbak, the traitor; the 'Blue' Mosque of Amir Aqsunqur, housing the tomb of Kujuk, sultan at the age of six but dead before adulthood; the twin minarets of al-Mu'ayyad Shaykh, who overindulged in wine; edifices endowed by viceroys of Syria, by court eunuchs, by rapacious military commanders, by noble women.

Beyond sprawls modern Cairo, devouring for miles around every inch of empty space from what used to be leisurely residential quarters, lakes and canals, gardens and groves, cemeteries; expanding uncontrollably, eating into the desert; eating into its own helpless historic districts too, into their muddy streets, crumbling houses, and abandoned ruins, over which the mosques, domes, and minarets keep their solemn, silent guard.

Sultan Barquq, page 38

The Mosque of Amir Khayrbak, page 68

Sultan al-Mu'ayyad Shaykh and his minarets, pages 10, 42

72

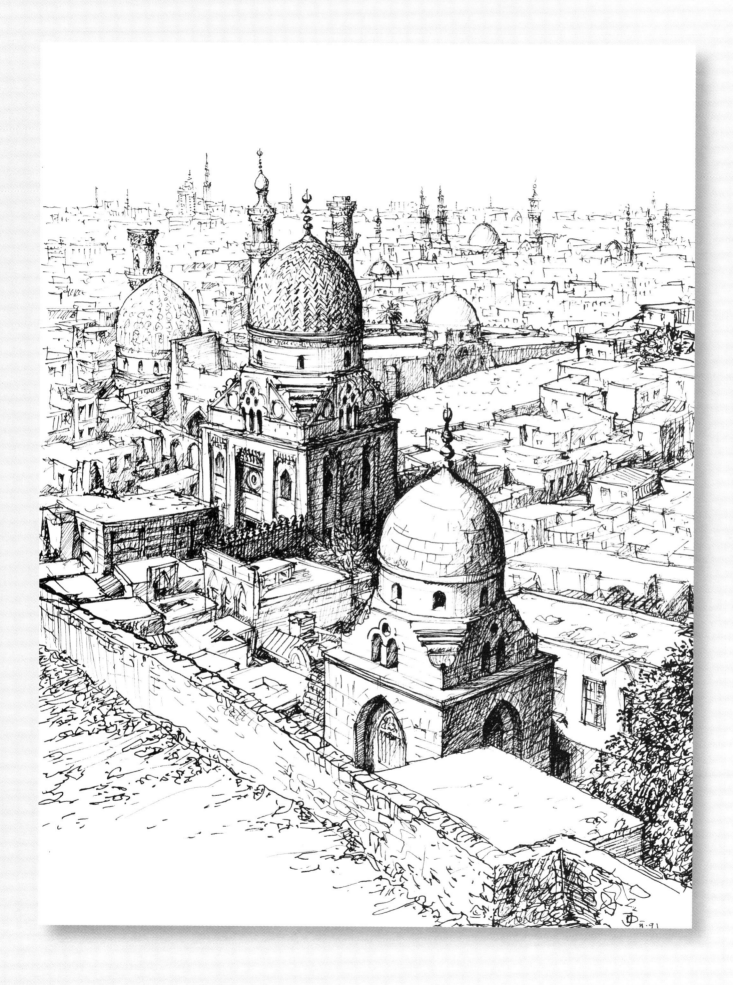

Takiya
Sulayman Pasha

DATE: 1543
INDEX NO.: 225
LOCATION: D-4: *al-Surugiya Street, next to Muhammad 'Ali (al-Qal'a) Street*

Sulayman Pasha's mosque at the Citadel, page 7

This is a façade of a Sufi convent, called *takiya* in Ottoman times, built in 1543 by Sulayman Pasha, the governor of Cairo, later the grand vizier in Istanbul to the Ottoman sultan Sulayman the Magnificent. This sketch of the *takiya*, made fourteen years ago, is already a document of history: the part of the façade to the left of the portal has since collapsed.

Preserving Cairo's architectural heritage is a race against time. This is a battle on many fronts, against overwhelming enemies of rising groundwater, polluted air, stone decay, insufficient infrastructure, overpopulation, inadequate laws, pressure of motorized traffic, ruthless modern development. It is fought by a painfully small and poorly equipped army whose officers have no clear strategy to follow. An Egyptian newspaper recently quoted a government official advising "a more practical solution to protect our archaeological heritage," after two thousand historic buildings were reportedly destroyed in the last few years. The recommended course of action was one in which "the government carries out a survey of historical villas, purchases them from their owners . . . and turns them into museums."

Individual buildings are being restored in Cairo, sometimes successfully. But the living medieval city as a whole is seldom perceived as valuable. Some vision for historic preservation other than 2,000 government-run museums needs to be found soon. If not, the result will be what a Cairo-based scholar, an authority on the city's architecture, predicted in 1995: "I do not expect, quite frankly, that twenty years from now there will be a historic zone left in Cairo. Where it once was, there will certainly be a few old buildings," but "tourists who want to see what remains of the medieval quarters of Cairo had better hurry. The fact is, we'd all better hurry."

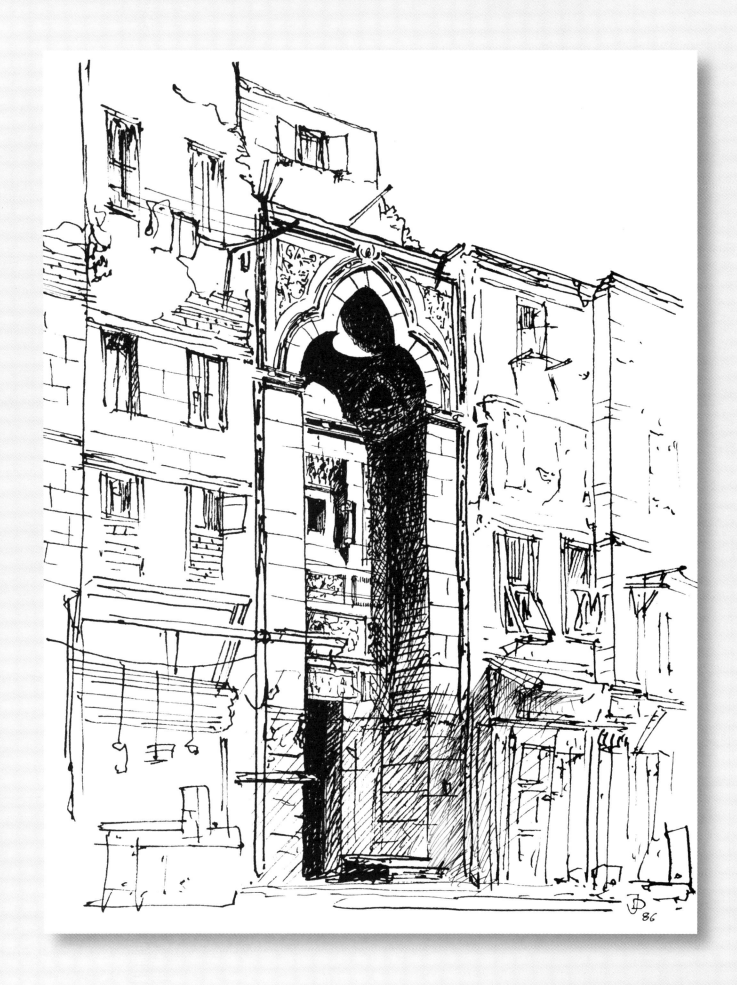

Sabil
Qitasbay

DATE: 1630

INDEX NO.: 16

LOCATION: E-2: *al-Gamaliya, at the corner of al-Gamaliya and al-Darb al-Asfar streets*

More about this type of building: see Sabil–Kuttab Ruqaya Dudu, page 82, and the sabil–kuttab at the Madrasa of Inal al-Yusufi, page 58

henever one strolls the streets of Cairo and sees a large bronze grille in the ground floor of an old building, with the lowest row of openings larger than the rest, it is invariably a *sabil* window, through which water was once dispensed as a charity. Even when the rest of the building has been completely altered, these windows are the telltale marks indicating where a *sabil–kuttab* once stood. At one time there were hundreds of these charitable foundations throughout the city; they can still be found in dozens. When the stone architecture of Cairo reached its zenith in late Mamluk times, each large religious complex founded by a sultan or an amir would have a *sabil–kuttab* attached at the corner where it was well exposed and easily accessible, and where a breeze would help to cool the water. By the time of the Ottoman conquest in 1517, the architectural form of the *sabil–kuttab* had been firmly established and highly standardized. Therefore, those constructed in early Ottoman times do not differ from their Mamluk predecessors, although the Ottoman ones were often endowed by private people and attached not to a mosque but to a house or commercial establishment.

This is the case with the *sabil–kuttab* founded by an officer named Qitasbay. It was built on the street parallel to the Qasaba, the city's main thoroughfare, when the latter, filled with sumptuous palaces and mosques, could accommodate no more commercial buildings. The *sabil–kuttab* is located next to the much earlier *khanqah* of Sultan Baybars, the corner of which, adorned with a monumental inscription, shows in the foreground. It was attached to a corner of a *wikala*, a wholesale trade center and a hostel for merchants. The building is just a ghost now. Only the ground floor remains, with a row of massive stone corbels that once supported upper stories bustling with activities.

Khanqah of Sultan Baybars II al-Gashankir, page 24

Most of the *wikala*s, formerly the very threads of Cairo's urban fabric, are in a similar state now. Many, although they have lost their upper floors, can still be recognized by their rows of shops and massive gates leading to once spacious courtyards (now usually built up with workshops and squatters' dwellings). Even these scant remnants are disappearing fast, giving way to concrete, aluminum, and fake classical architecture in genuine polished marble.

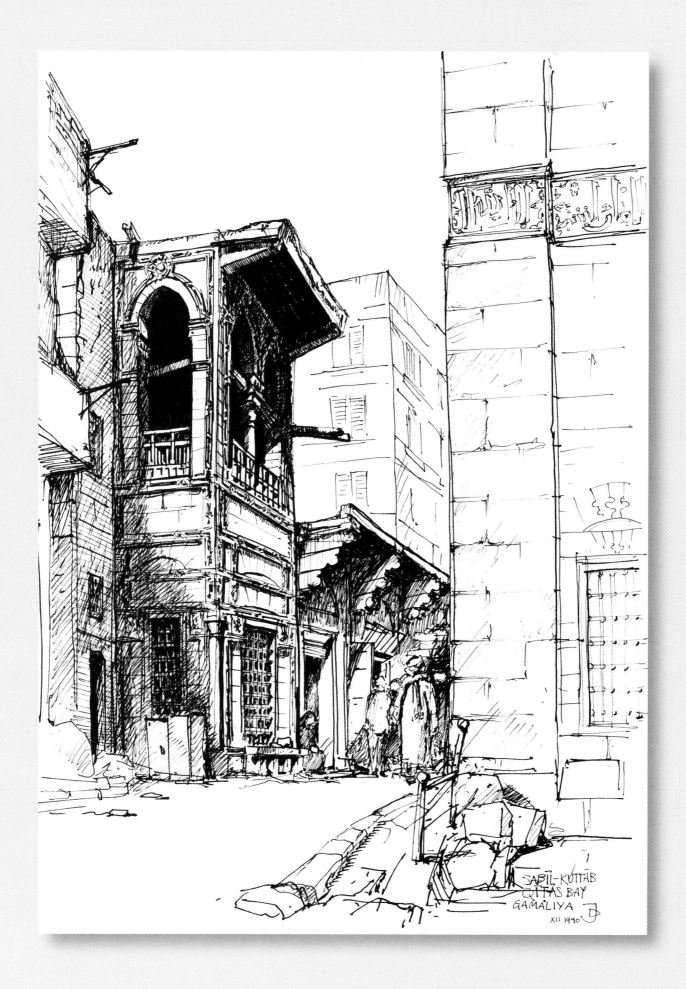

SABĪL-KUTTĀB
QITĀS BAY
GAMALIYA
XII 1990

Khanqah
Shahin al-Khalawati

DATE: 1538
INDEX NO.: 97
LOCATION: F-5: *at the foot of the Muqattam Hills, above the Southern Cemetery*

78

The cemeteries:
see page 40

In stark contrast to the maddening noise and neverending commotion of the city, the vast cemeteries of Cairo overwhelm the visitor with their timeless tranquillity. Although thousands live and work in the Cities of the Dead, these dusty expanses are calm and empty. The long unused and ruined *khanqah*, or Sufi convent, clinging to the barren rocky slopes of the Muqattam Hills fits well in the landscape of desolation located so close to some of the world's busiest streets.

The *khanqah* is named after a man who had been a *mamluk* of Sultan Qaytbay, but rather than pursue a military career, preferred to study in the Khalawati mystic order in the Iranian city of Tabriz. He was later buried in the convent he founded and led in Cairo.

Shahin al-Khalawati's life spanned Egypt's transition from sovereign Mamluk sultanate to the subject of Ottoman rule. The building he founded, although Ottoman by date, shares with other contemporary structures the characteristic of carrying over from the previous period all well-established techniques of stonemasonry and architectural patterns, with a noticeable exception: the minaret. The conical, pencil-like top was to become a hallmark of Ottoman minarets, adding another chapter to the story of change and continuity inscribed on the skyline of Cairo. However, even here the earlier tradition can be traced in the division of the tower into three tiers separated by balconies. This was the established design in Mamluk times, and it proved very persistent.

The Zawiya and Tomb
of
Shaykh Sinan

DATE: 1585

INDEX NO.: 41

LOCATION: D-2: *al-Gamaliya, Darb al-Qirmiz*

80

The Fatimids and al-Qahira: see Bab Zuwayla, pages 8, 10

Al-Gamaliya is the very heart of medieval Cairo, a district located right in the middle of al-Qahira, where the Fatimids once ruled over their empire. The whole royal enclosure of al-Qahira was meant to be a palatial city reserved for the rulers and their court; ordinary people lived in the earlier city at al-Fustat and were obliged to leave the royal precinct by sunset. In Cairo, however, enterprise, wit, and common sense have always won over ceremony. By the twelfth century people were living and trading in al-Qahira. When Salah al-Din (Saladin) put an end to Fatimid rule in 1171, the seat of power moved to the Citadel, leaving al-Qahira, with al-Gamaliya as its hub, entirely to trade and commerce. Sumptuous mosques lined the main thoroughfare where the Fatimid palaces had been, and side lanes teemed with great and small commercial buildings and houses. The tomb of Shaykh Sinan, a venerated Sufi, stands in one such side alley named Darb al-Qirmiz, or Crimson Alley. Centuries of busy activity have caused the street level to rise almost two meters since it was built, making the building look even smaller and more lost among the surrounding houses.

DARB EL QIRMIZ

Sabil–Kuttab
Ruqaya Dudu

DATE: 1761
INDEX NO.: 337
LOCATION: D-4: *Suq al-Silah Street*

Sabil–Kuttab Nafisa al-Bayda, page 84

Sabil Qitasbay, page 76

Sabil–kuttab at the Madrasa of Inal al-Yusufi, page 58

*I*n 1758, a rich woman named Badawiya Shahin lost a daughter. The mother's grief was deep, and the lady had sufficient means to turn it into a lasting mark in stone. She built an ornate tomb for her daughter Ruqaya (whose nickname Dudu means parrot), and a few years later endowed a *sabil–kuttab* in her name, one of the most beautiful in the city.

The *sabil–kuttab* is a uniquely Cairene combination of a public fountain and an elementary school in one building. On the ground floor, thirsty passersby could take water from brass mugs chained to ornate window grilles, a welcome charity in the scorching Egyptian heat. These were the times before municipal mains, in a city where well water was brackish, and drinking water brought from the Nile had to be paid for. Each *sabil* had a huge underground cistern that was filled once a year in the flood season from water-bags carried on camels. Water from the cistern was cooled and aerated as it cascaded down a carved marble slab, then was distributed from marble basins. On the upper floor was a lofty open loggia where children learned to read and write. They also memorized the Quran, a pious task in itself, but also a means to learn classical Arabic, a language quite different from colloquial Egyptian.

The salaries of the teacher and the *sabil* attendants, as well as the maintenance costs, were all paid from an endowment, called a *waqf*, established by the founder. Virtually all religious buildings in Cairo were part of a *waqf*, to which the owner, according to detailed prescripts of Islamic law, perpetually assigned income-generating property, such as lots of land or rents from buildings. The founder allocated the income to a charity or a religious institution, establishing salaries for the personnel and naming the beneficiaries. This was a noble act of piety, but also a way to protect one's property against confiscation or fragmentation among inheritors. It was also a good way to commemorate a loved one, such as Lady Badawiya's daughter Ruqaya Dudu, or to publicize one's own name on a dedicatory inscription carved in marble. Nowadays, the *sabils* are no longer in use, but at every station in the Cairo subway, there is at least one drinking-fountain distributing cold water: a metal box with hand-painted letters stating who provided this charitable service to the public.

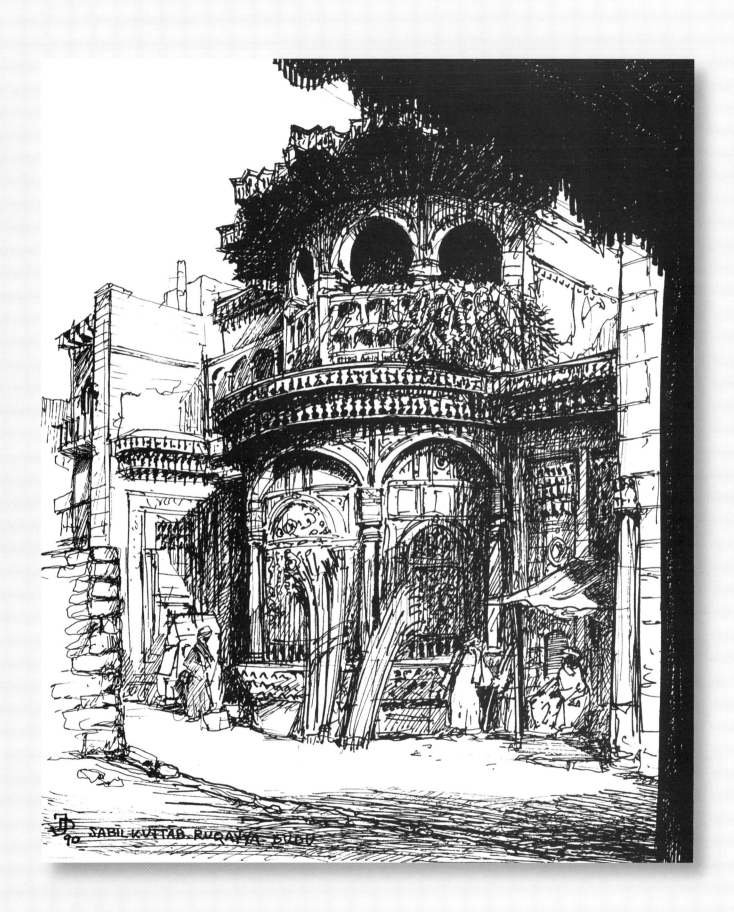

SABIL KUTTAB RUQAYYA DUDU

Sabil–Kuttab
Nafisa al-Bayda

DATE: 1796

INDEX NO.: 358

LOCATION: D-2: *al-Mu'izz li-Din Allah Street (the Qasaba), on the corner of al-Sukkariya Street, next to Bab Zuwayla*

Bab Zuwayla, page 8

Sabil–Kuttab Ruqaya Dudu, page 82

"A fountain of bliss and beauty. Glory and prosperity to the beneficent lady" In the middle of the rich façade, a marble panel with this Arabic poem praises a woman who came to Cairo as a slave. Nafisa was sold to 'Ali Bey, a powerful Mamluk who later freed and married her. The time was the late eighteenth century. The military oligarchy of the Mamluks effectively ruled Egypt, nominally subject to the Ottoman sultan, but the beys, with their private armies, were in a constant feud. When 'Ali Bey was killed in a battle in the ceaseless fight for power, Nafisa immediately married the victor, Murad Bey. Married to Egypt's most powerful man, she also inherited immense wealth from her first husband. She owned property and endowed charities in her own name; the *sabil–kuttab* next to Bab Zuwayla is one of them.

When Napoleon Bonaparte invaded Egypt in 1798, Murad led the Mamluk army against the French. Defeated in the Battle of the Pyramids, Murad retreated to Upper Egypt with his remaining troops. Nafisa remained in Cairo and negotiated between her husband and the French, sometimes signaling from the rooftop of her palace to Murad, who would come to Giza and receive the messages at the top of the Great Pyramid. She hosted Napoleon himself at a dinner and was offered precious gifts (which she was later forced to return). Whatever success her diplomatic effort achieved, it was short-lived. Soon Murad was dead of plague, and the French army withdrew from Egypt. Nafisa remained a respected lady until her death in 1815, although her wealth dwindled.

Nafisa inserted her *sabil–kuttab* into a medieval *wikala*, a large commercial establishment. She gave it a new façade, with the rounded *sabil–kuttab* in the corner where the charity commemorating her name could be seen best. In the medieval setting appeared a building resembling the contemporary *sabil*s of imperial Istanbul and elegantly blending the innovative architectural form with the centuries-old local tradition of carved stone decoration.

The building, which by the 1990s was dilapidated and on the verge of collapse, was restored in 1996–98 by the American Research Center in Egypt. The neighborhood was quick to give the fair-haired woman who directed the conservation the nickname 'Nafisa.'

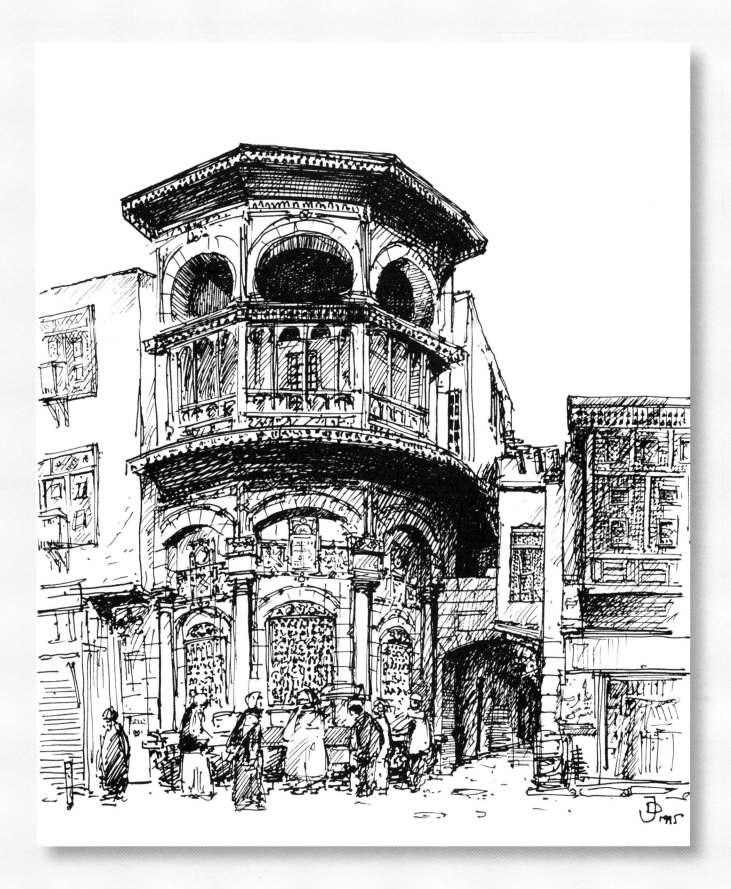

House
of
Ahmad Katkhuda al-Razzaz

DATE: 15TH–19TH CENTURIES
INDEX NO.: 235
LOCATION: D-3/4: *al-Darb al-Ahmar district, between al-Darb al-Ahmar (al-Tabbana) and Suq al-Silah streets*

Al-Darb al-Ahmar and the vicinity of the house, page 36

House of Gamal al-Din al-Dhahabi, page 88

A huge rectangular block of a building rises high over al-Darb al-Ahmar Street. Enormous surfaces of elaborate turned-wood screens and stained-glass panels indicate a sumptuous hall inside, taking up the entire upper floor. The view is impressive, but it is also misleading, giving no indication of the true size of the house of which this unit is just a part. The immense lot stretches across a whole block between two important streets. It contains a multitude of halls, rooms, courtyards, corridors, staircases, and passages that belonged to at least two different houses, separated by a street that has long since been completely incorporated into the house. This veritable maze was the result of centuries of constant occupation, each generation leaving its mark by rebuilding and adding on. Some medieval remnants can still be seen in each of the house's two main courtyards, distinguished by excellent craftsmanship in stonemasonry. One of them is a gateway adorned with Sultan Qaytbay's blazons and monumental inscriptions. Another is an enormous medieval reception hall, redecorated many times. The master of the house would entertain his guest by the marble fountain in the middle of the room while the ladies of the *harim* looked from behind wooden screens on the balconies above, where the upper floors were reserved for women. Every house was strictly divided between the *salamlik* on the lower floor and the *harim*, the private, secluded part of the house, a sanctuary where no male guests would be admitted. The division is still present, but the apartment blocks of today are much less suited for the needs of a traditional family lifestyle than the courtyard houses of the past were.

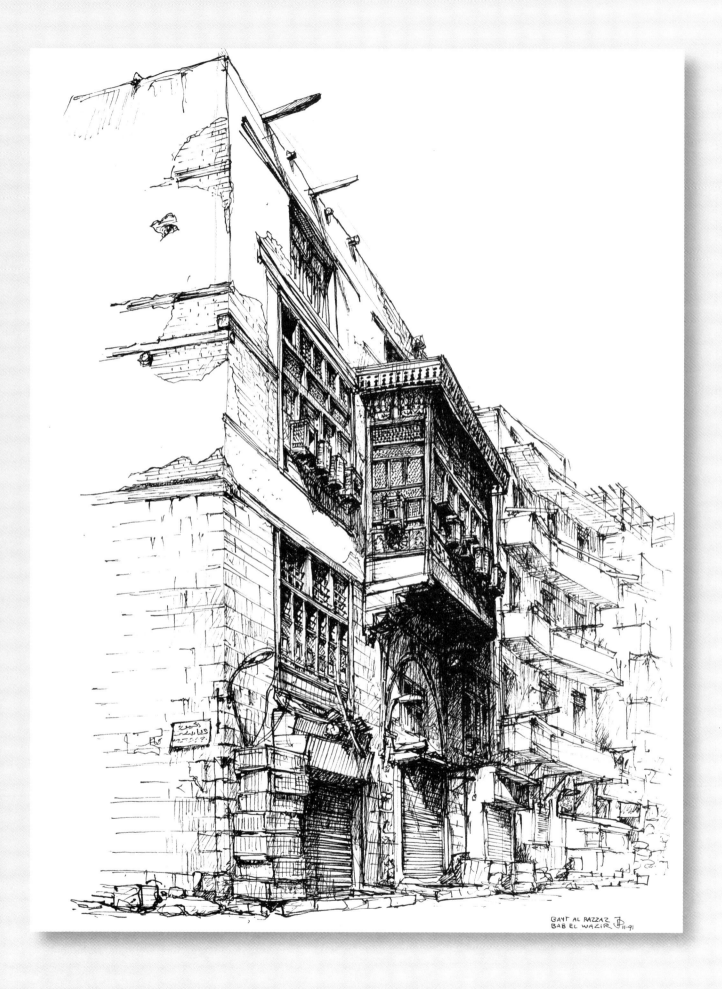

BAYT AL RAZZAZ
BAB EL WAZIR 11-91

House
of Gamal al-Din al-Dhahabi
Mashrabiya Balcony in the Courtyard

DATE: 1637

INDEX NO.: 72

LOCATION: D-3: *al-Darb al-Ahmar district, Khushqadam Street (off al-Muʿizz li-Din Allah Street)*

"She went to the side of the balcony overlooking Palace Walk. She peered through the grille with interest and longing. . . . She did not have long to wait, for a young police officer appeared from the corner of al-Khurunfush Street. At that, the girl . . . turned the knob and opened the two panels a crack, her heart pounding. . . . When the officer neared the house, he raised his eyes cautiously but not his head, for in Egypt in those days it was not considered proper to raise your head in such circumstances."

Few people know the heart and soul of Cairo as intimately as Naguib Mahfouz, a Cairene and a laureate of the Nobel Prize in literature. It is natural then that this fragment from his novel captures the essence of an important function of the *mashrabiya*, a covered balcony of turned-wood grilles. Behind its screen, respectable women could participate in social life from within the confines of the house without compromising their modesty. (Although, we learn from the novel, it could not protect against a heartbreak.)

This was an important function of the balconies, but not the only one. The name *mashrabiya* hints at another: it derives from a word meaning 'to drink,' for earthenware jars containing drinking water were kept in these open-work wooden structures, where evaporation through the porous sides of the jars kept water cool while providing fairly efficient air conditioning for the interiors. The balconies were also the principal ornament of the façades. Hundreds of them defined the character of the streets of Cairo until fairly recently. Nowadays, most have perished. Although the traditional *mashrabiya* bays no longer adorn new houses in Cairo, the art of making turned-wood panels is alive. They are not only popular in Egyptian furniture, but contemporary architects also use them in modern buildings, sometimes with excellent results.

Compare to al-Khiyamiya Street, page 94, and the House of Ahmad Katkhuda al-Razzaz, page 86

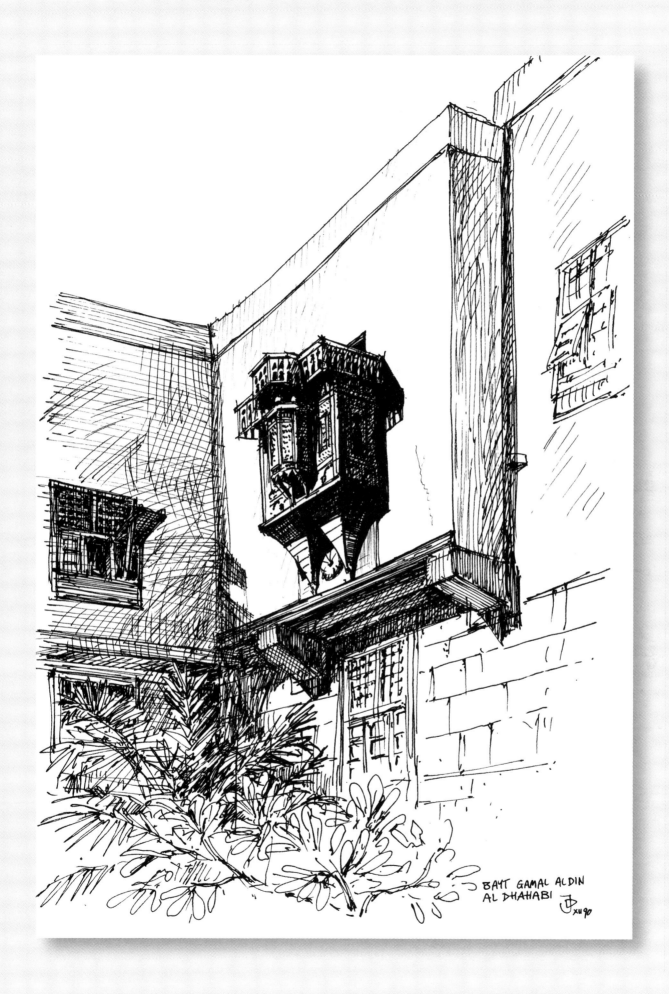

BAYT GAMAL AL DIN
AL DHAHABI

House
of
Gamal al-Din al-Dhahabi

DATE: 1637
INDEX NO.: 72
LOCATION: D-3: *al-Darb al-Ahmar district, Khushqadam Street (off al-Muʿizz li-Din Allah Street)*

House of Gamal al-Din al-Dhahabi: Mashrabiya Balcony in the Courtyard, page 88

Gamal al-Din was the head of Cairo's goldsmiths' guild in the seventeenth century, hence he was known as al-Dhahabi, or 'Golden,' an appropriate name for an apparently very rich man. The building he constructed around 1637 is one of the few surviving merchant houses of the Ottoman period. It is a good example of how most streets in Cairo looked then, and well into the nineteenth century.

To the street the house displayed the blank stone walls of the ground floor, pierced by an entrance gate. Over it, massive stone corbels carried the upper stories. They were not designed as a decorative façade, but merely reflected the internal arrangement. Elaborate wooden balconies overlooked the streets, but they too were not meant to be external ornaments: they were parts of the interiors, from which ladies of the *harim* could observe the life of the street. From outside, it was not even possible to guess the size of the building, which was arranged around a courtyard. This was the heart of the house, the focal point for the household. Here in the courtyard merchants would display their wares, guests would be met, and goods unloaded to be stored in the ground-floor storerooms. The master of the house oversaw all this activity from the *maqʿad*, an elevated arcaded loggia. Reception halls and other rooms were also grouped around the courtyard.

The internal focus of merchant houses was in keeping with the general inward-oriented nature of Islamic architecture. Even monumental edifices displayed their façades to internal courtyards rather than to the streets. Quite tragically, in Egypt and many other Muslim countries today, on the ill advice of city planners and preservationists, the areas around historic buildings are bulldozed clear in a misguided attempt to follow ideas conceived in a different cultural context for very different monuments.

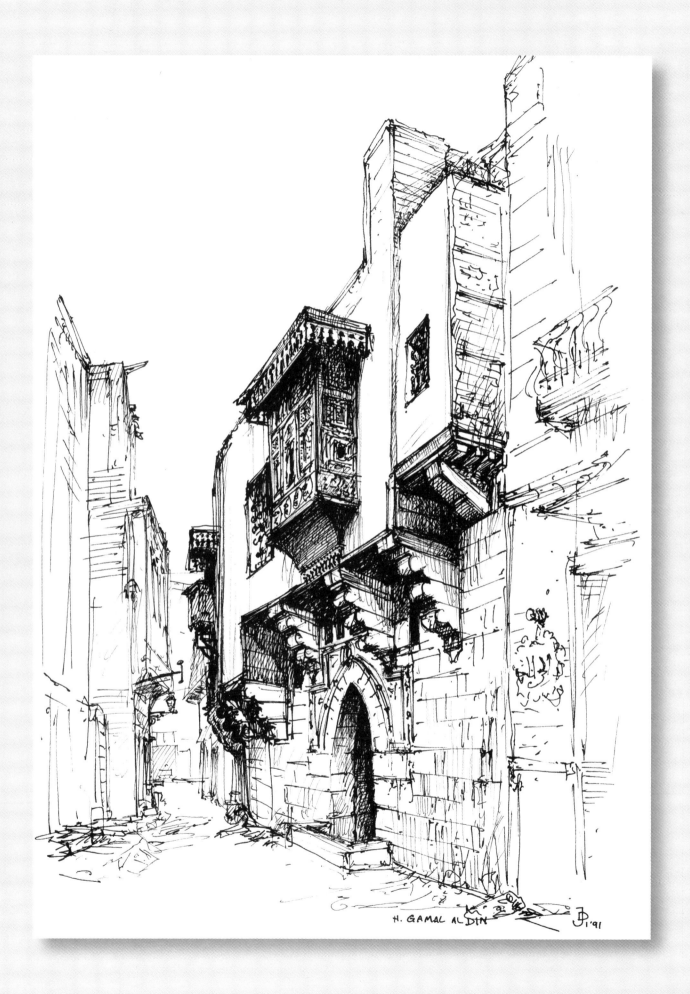

H. GAMAL AL DIN

Sa'd Allah Lane

LOCATION: D/E-3: *al-Darb al-Ahmar district*

*See a surviving gate
of a hara next to
Sabil–Kuttab Nafisa
al-Bayda, page 84*

here are no registered monuments in Sa'd Allah Lane. It has preserved, though, something perhaps more historically important than any particular building (even though some of the houses are about a hundred and fifty years old), and that is the spirit of the alley (*hara* in Arabic) as an urban unit. Unlike Western cities, Cairo was until quite recently a collection of such units, each centered around an alley that usually branched into several cul-de-sacs. The alleys themselves were entered through gates from the few thoroughfares. Every night, the gates were closed, turning the city into a host of separate, autonomous units. In daytime, too, these units were quite self-contained. With a baker, grocer, notary, shoemaker, and tailor at hand, a mosque close by, and local gossip in constant circulation, people hardly needed to leave the familiar environments of their own alleys. The alley also had its shaykh, who represented the community to authorities and was responsible for law and order. There would be a neighborhood strongman, too, who might demand some protection money but made sure that no stranger did any harm to his neighbors. Even today, Cairo is a remarkably safe city.

Now the alleys are no longer administrative units, and the rapidly changing pace of life has left its mark on the urban organism. Gates no longer shut the alleys off at night, but people still live their lives within their streets and alleys as they have done for generations. The tradition is so strong that the pattern of self-contained neighborhood units has been carried over to modern, well-off districts. Cairo can still justly be described as a city of a thousand villages.

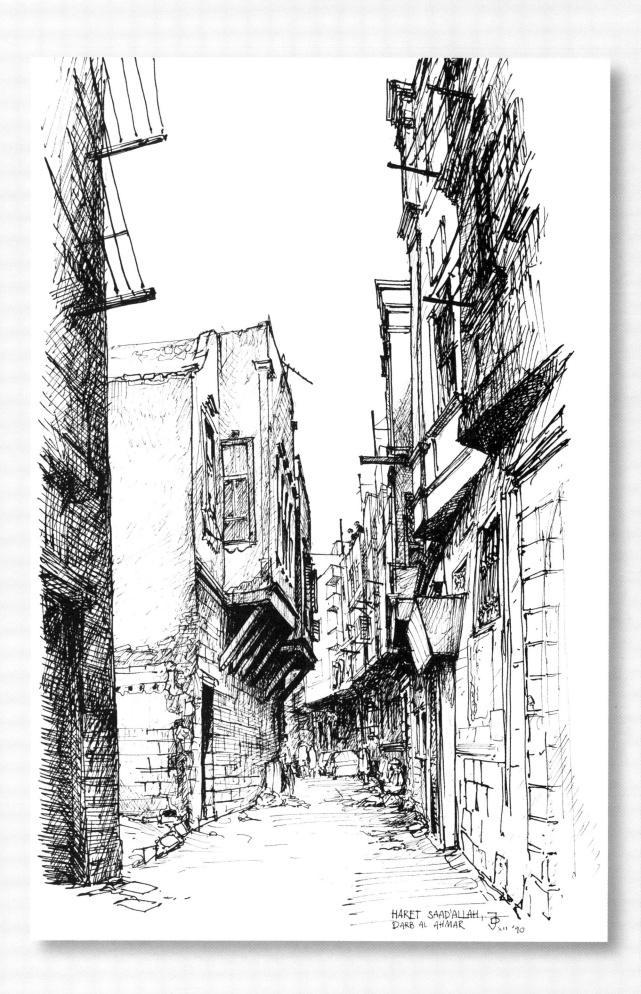

HARET SAAD'ALLAH,
DARB AL AHMAR

Al-Khiyamiya Street
the Tentmakers' Bazaar

DATE: MID-17TH CENTURY (RADWAN BEY'S COVERED BAZAAR)
INDEX NO.: 406, 407 (COVERED BAZAAR)
LOCATION: D-3: *al-Darb al-Ahmar district, directly opposite Bab Zuwayla*

Wikala: see Sabil Qitasbay, page 76

Enclosed bazaars, where dome-covered streets integrate whole commercial districts, are a striking urban feature in the great Islamic cities of Asia such as Aleppo or Isfahan. Apparently this was never the case in Cairo. Was it because serious trade was done in *wikalas* rather than in street shops? Or because of different architectural traditions? Or for still other reasons? The question must be left open to the historians.

This does not mean that Cairo merchants traded under the blazing sun. Many thoroughfares had important stretches covered with wooden roofs. Some can still be seen in nineteenth-century drawings. Now most are gone, but on a summer day, canvas shades are still hung across big parts of the medieval city's narrow main street.

Cairo's last covered market is the Tentmakers' Bazaar, al-Khiyamiya, where, in accordance with its ancient name, fabrics are sold, from simple canvas tents and covers to masterful appliqué work. This continuity of both medieval names and traditional distribution of crafts and trades is a remarkable feature of historic Cairo. One still goes to the Chicken Street for poultry or to the Coppersmiths' for a metal table tray. There is still a street called Between the Two Walls, although one of these city walls ceased to exist over eight hundred years ago.

Bab Zuwayla, pages 8, 10

The Tentmakers' Bazaar was built by Radwan Bey, who held the post of *shaykh al-balad* (elder of the town) under nominal authority of the Ottoman governor, but was de facto ruler of the country for twenty-five years. His complex of buildings comprised rows of shops and residential units for merchants, two mosques, workshops and stables, and Radwan's own palace. Built right in front of Bab Zuwayla, it complemented an urban environment that was already rich in earlier monuments, and continued to flourish. The amazing mixture of different architectural styles, palaces and shacks, rags and riches, is still here to be seen, felt, smelled, and heard.

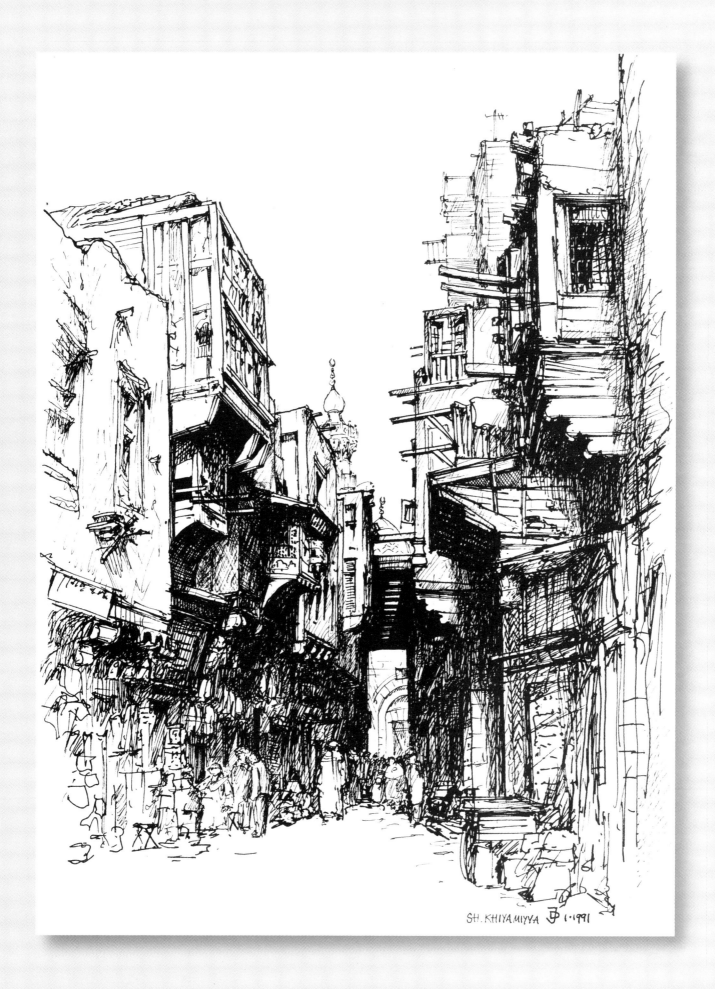

SH. KHIYA.MIYYA 1.1991

The Door
of
Takiya al-Rifaʻiya, Bulaq

DATE: 1744
INDEX NO.: 442
LOCATION: A-1: *Bulaq, next to the mosque of Sinan Pasha*

Compare to
Sabil–Kuttab Nafisa
al-Bayda, page 84

Khanqah of Sultan
Baybars II al-
Gashankir, page 24
Khanqah Shahin al-
Khalawati, page 78

*I*n the Islamic artistic tradition, which avoids figural representation, geometric decoration has a special place. The omnipresence of interlacing linear patterns gives a remarkable visual unity to art and architecture from the Atlantic coast of Morocco to Uzbekistan, and from Moorish Spain deep into the African continent. In Cairo, one of the favorite motifs was knotted string moldings carved on the stone façades. They were the hallmark of Mamluk architecture. After the Turkish conquest, a lot changed in Egypt, but the stone decoration remained almost the same, even on buildings that directly imitated Turkish models in other respects. A trained eye can tell the later, Ottoman ornaments by their increased complexity and angularity, but otherwise the continuity of style over the centuries is remarkable.

The portal shown here leads to an eighteenth-century *takiya*, a building housing a convent of Sufi dervishes. (Earlier, such establishments were known as *khanqahs*.) It stands next to the Mosque of Sinan Pasha in Bulaq, once Cairo's main river harbor. The Nile bed gradually shifted west, away from Cairo, which was originally built next to its bank. The river was the vital artery of the country, crucial for Egypt's economy. Almost all travelers arrived by ship and entered Cairo through the port of Bulaq, first built in the late Middle Ages on the ground deposited by the river. Even in the mid-nineteenth century, Bulaq was a separate town, with a distinctly commercial character. Today, its landscape is schizophrenic. At the feet of the office towers, shopping malls, and big hotels that have mushroomed along the bank of the Nile, the small-town alleys, rustic metalwork shops, and colorful secondhand clothing markets of Bulaq squat helplessly, doomed to succumb to the invasion of cement and steel.

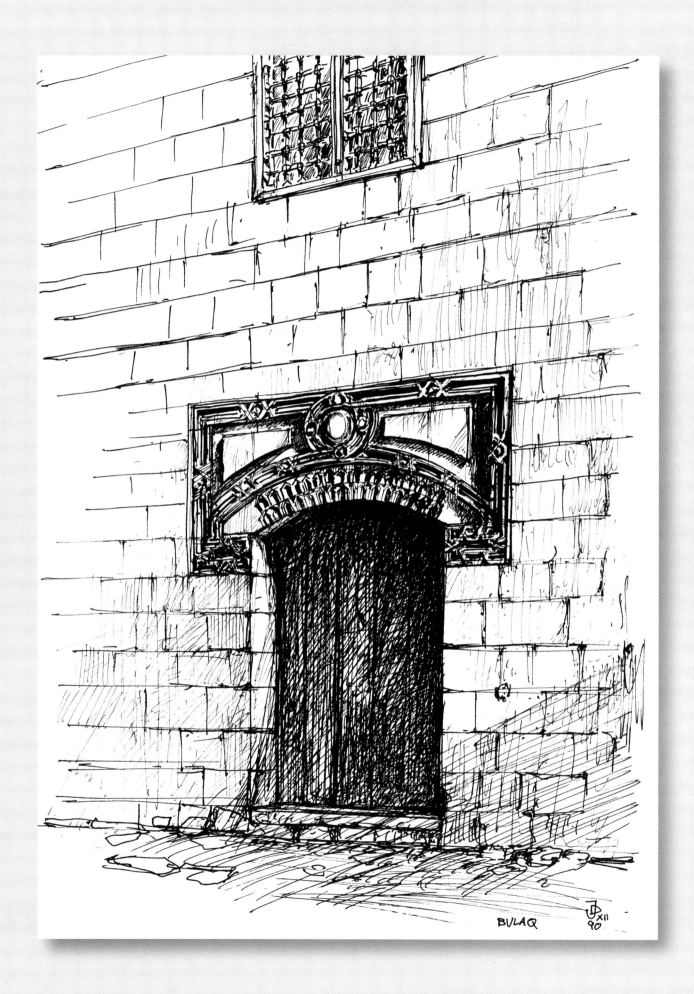

BULAQ

The Mosque
of
Alti Barmaq

DATE: 1711
INDEX No.: 126
LOCATION: *D-4: off Suq al-Silah Street*

Compare to the Mosque of Qagmas al-Ishaqi, pages 52, 54

Takiya al-Rifa'iya, page 96

he austere masonry of the mosque of Alti Barmaq is a far cry from the stone wonders of the Mamluk heyday. Simple undecorated recesses replaced the elaborate stalactite hoods of the Mamluk façades. Carved floral scrolls, inscription bands, and marble inlays no longer adorn the walls and dome. The simple minaret is a very poor cousin of the earlier ones, dressed in their lace-like carved patterns and crowned with gracious pavilions on marble columns. Still, even this modest neighborhood mosque displays stonemasonry of very good quality.

After the Ottoman conquest, there was no more royal patronage, nor any amirs of the sultan's court wishing to commemorate their names in stone buildings. The Turkish governors were usually more interested in the prospects of their future careers in Istanbul than with adorning a city where they were only temporarily posted. However, stonemasons were still busy in Cairo. The new mosques often had plans based on Turkish models, but the decoration remained in Mamluk style for centuries. After all, the patrons were still Mamluk beys, even if nominally subject to Ottoman rule. The skills perfected in the Middle Ages never died out, neither when the mosque of Alti Barmaq was built, nor even today. One can still see stonecutters working in perfect harmony with their heavy, medieval tools, carving stones right on the sidewalk by a historic monument or a modern building. As long as one also sees beside them their sons learning the secrets of the trade from a very early age, the centuries-old craft will not become extinct.

The small and plain mosque of Alti Barmaq ('six fingers') has unusually little of the traditional Mamluk style. Nevertheless, there is undeniable charm in its solid stone pillars and cross vaults, in the simplicity of its façades, in the colorful floral tiles lining the sanctuary wall. Following an old tradition, the prayer hall is raised over a row of shops, which are still busy with assorted crafts and trades. Inseparable from its community, rooted in its neighborhood, the modest building defies the passage of time and the hastened pace of life in the modern streets choking with traffic so close by, and still so distant.

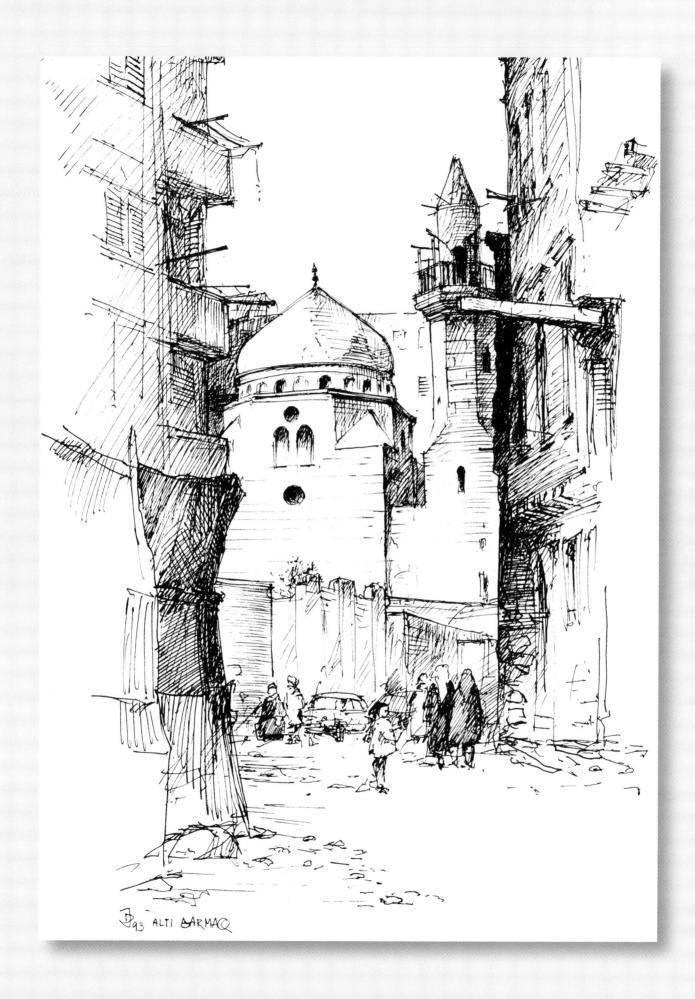

JB 93 ALTI ΔARMAQ

The Mosque *of*
Muhammad 'Ali
at the Citadel, from al-Saliba Street

DATE:	1171 (CITADEL); 1830–57 (MOSQUE)
INDEX NO.:	503 (MOSQUE)
LOCATION:	E-4: *the Citadel*

Cairo is a profoundly ambiguous city. It has preserved an exceptional number of medieval buildings; the Mamluk domes and minarets still set the tone for the city's skyline. Structures many hundreds of years old are found here by the score, and Saliba Street alone has them by dozens. Yet Cairo's most conspicuous landmark, the Mosque of Muhammad 'Ali at the Citadel, is a creation of the mid-nineteenth century. Even though Cairo developed its own original architectural style, this mosque owes nothing to that centuries-old tradition. The slender pointed minarets and the cupolas ascending toward the huge central dome are the hallmarks not of Egyptian, but of Turkish Ottoman architecture. But thanks to coins, postcards, and photographs, the silhouette of Muhammad 'Ali's mosque has become a symbol of Cairo.

The mosque dominates the Citadel, rising high on an enormous platform that entombed the Mamluk royal palaces. The scholars who came to Egypt with Napoleon Bonaparte had the opportunity to depict in the *Description de l'Egypte* giant ruined halls whose tall columns and monumental arches dwarfed the people and camels wandering around them. Soon after the last volume of the *Description* was printed, these colossal remnants were buried in rubble to provide firm footing for the ambitious project of Egypt's new ruler.

The building was designed to resemble the great imperial mosques of Istanbul. Muhammad 'Ali, the absolute ruler of Egypt for almost thirty years, was nominally subject to the Ottoman sultan, but in reality, he spent his lifetime creating in Egypt a sovereign dominion for himself and his descendants. Yet for his mosque, he chose the style emulating Istanbul, the Ottoman metropolis. Was he aware that in doing so, he followed the steps of an ancient predecessor? When Ahmad ibn Tulun, the first independent ruler of Islamic Egypt, built his monumental mosque in Cairo, he imitated the architectural style of another distant imperial capital, even though he had broken away from his political overlords. Muhammad 'Ali did the same nine hundred and fifty years later. In spite of all ambiguity, there is a powerful current of continuity in Cairo.

Ahmad ibn Tulun and his mosque, page 4

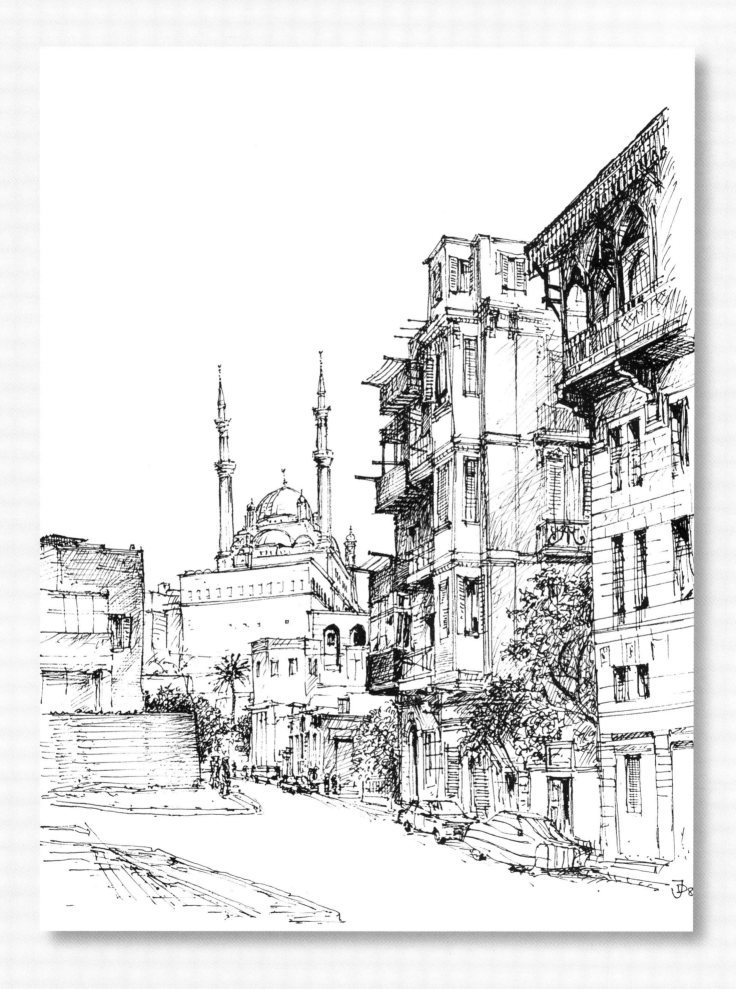

Residential Building
on
Ibrahim al-Laqqani Street

DATE: 1910
LOCATION: *Ibrahim al-Laqqani Street (formerly Boulevard 'Abbas), Heliopolis
 (Masr al-Gadida), outside the map*

The view of the courtyard in the Madrasa of Sultan Barquq, drawn fifteen years earlier, in 1985, see page 26

This is the last drawing in the book. It is also the last to have been done, dated June 2000, a full 1,359 years into Cairo's history. The subject is different as well.

Unlike the other buildings portrayed on these pages, this one is not a monument of Islamic architecture in the medieval city, though it masterfully blends different motifs from ancient mosques and houses of Cairo.

The other drawings I made sitting in outdoor cafés or on sidewalks, in mosques or on minarets, amid friendly, interested passersby, noisily curious children, unconcerned cats. This one I sketched in the comfort of a familiar room: it is the view from the window of my apartment in Heliopolis.

The street below is full of trash and crowded with a noisy throng of people and cars (in other cities, cars and people do not mix as easily as in Cairo), but our neighbors remember times when a passing automobile aroused curiosity. The building opposite my window was among the first to be built in the district, which was designed as a green, spacious, modern, and elegant alternative to the bustle of the old city. When the house was constructed in 1910, most of the land around was still barren desert. Its Belgian architect, Ernest Jaspar, worked to fulfill the vision of another Belgian, Baron Edouard Empain, the founder of Heliopolis. When the baron first approached the ruler of Egypt, Khedive 'Abbas, with the proposal for the project, some members of the royal family could not understand: rather than ask for favors, the man wanted an empty piece of the desert, and moreover, he wished to pay for it. Before long—remembers a younger member of the royal family—they started to regret that the khedive had not asked a higher price. Today, Heliopolis is home to both the president of the republic and the descendants of the khedives. It is here, too, that this book has been written.

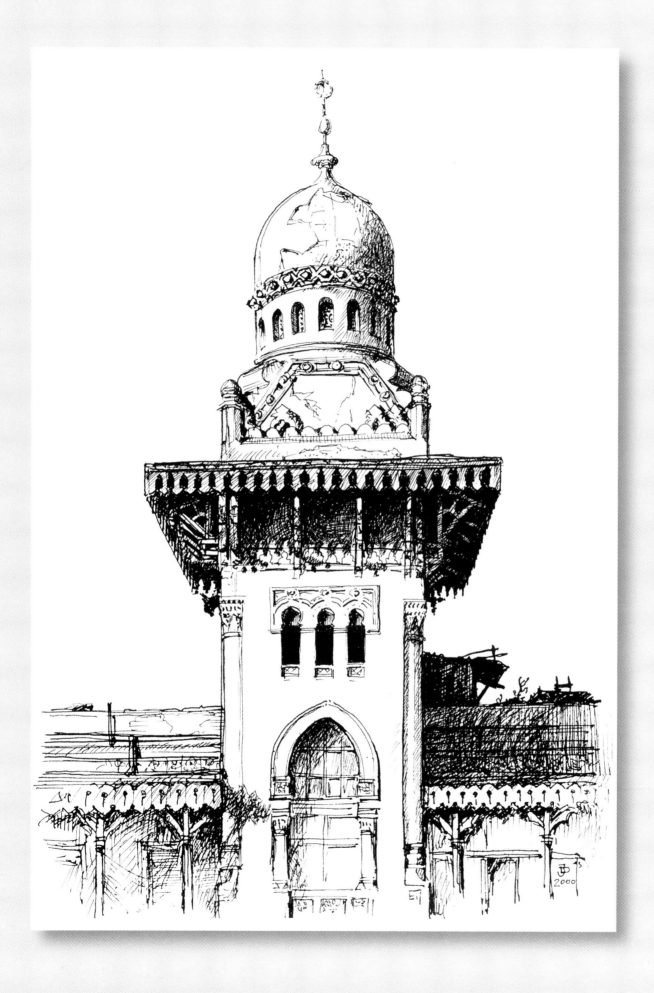

Glossary of Names and Terms

The Beginnings

In A.D. 639, an Arab army of about ten thousand people conquered Egypt, at the time a province of the Byzantine Empire. Within a few centuries, the majority of the country's large Coptic Christian population gradually converted to Islam and adopted the Arabic language. Egypt was a province in an empire extending from Persia to Spain and ruled by a **CALIPH,** the spiritual leader of Islam and the suzerain of the empire. Immediately after the conquest, the Arabs moved the capital from Alexandria to **AL-FUSTAT,** a new military encampment that soon developed into a thriving city, the nucleus of today's Cairo. **AHMAD IBN TULUN,** an independent ruler of Egypt from 868, established a new urban settlement outside the existing city, a pattern that was to be repeated many times in Cairo. He founded a short-lived dynasty, but after 905, Egypt was again ruled by the caliph's governors.

Al-Qahira

The **FATIMIDS** were a dynasty of Shiite Muslims who aspired to the leadership of all Islam. In Cairo, they established the capital of a Shiite caliphate, challenging the Sunni, or orthodox, caliph of Baghdad. They invaded from North Africa in 969 and immediately set out to build **AL-QAHIRA,** the fortified enclosure north of the existing town, a royal city reserved for the caliph, his court, and guards. The name al-Qahira, of which Cairo is a corruption, applied to a part of a larger urban organism called **MISR,** a name that then as now designated not only the city but the whole country of Egypt.

Salah al-Din

Known as Saladin to the Europeans, this valiant commander of Sunni forces put an end to the Fatimid rule. He made Cairo the capital of a state comprising Egypt and Syria (which included Palestine). He and his descendants reigned with the title of **SULTAN,** roughly equivalent to 'king.' Salah al-Din built the **CITADEL OF CAIRO,** a fortress overlooking the city, where its rulers resided for more than six hundred years. By then, al-Qahira was no longer a royal city, but a commercial and residential center.

Glossary of Names and Terms

The Mamluks

Mamluk sultans ruled Egypt from 1250 until 1517. **MAMLUKS** were elite soldiers brought to Egypt in childhood as slaves from non-Muslim countries, primarily from Turkish-speaking southwestern Asia. They received religious and military instruction in the service of their master, the sultan or an amir. **AMIR** means roughly a prince or a baron, a dignitary holding state offices. Able *mamluk*s were manumitted and could advance to become amirs, who elected a sultan from among themselves. The Mamluks, although ruthless and rapacious, were great patrons of the arts. Under their rule, different building types in Cairo were mastered to architectural perfection: **MADRASA**, a Quranic school; **SABIL–KUTTAB**, a public drinking fountain combined with an elementary school; **WIKALA**, a commercial establishment for wholesale trade, with a hostel for merchants; and **ZAWIYA**, a small prayer hall usually for a Sufi community. **SUFI** orders of religious mystics seeking revelation in special rituals were numerous in Mamluk and Ottoman times.

The Ottomans and Later

Egypt was conquered by the Turkish Ottoman Empire in 1517 and governed by a **PASHA**, a governor appointed by the sultan residing in Istanbul. With weak central control, Mamluks, now with the Turkish title of **BEY**, were still the de facto rulers. Cairo was no longer a capital, but it remained a thriving and populous commercial center. **MUHAMMAD 'ALI** came to power after the French, under Napoleon Bonaparte, invaded in 1798, then retreated. With Muhammad 'Ali's leadership, Egypt entered a new phase of modernization and westernization. A continuous line of medieval architectural tradition was terminated. From the 1860s on, under Muhammad 'Ali's grandson Isma'il, wide avenues were laid out and lined with European-style buildings, but this center of modern Cairo has been built on land granted by the shifting course of the Nile, and the historic districts were left largely intact.